C000180562

RIHANNA
and the clothes she wears

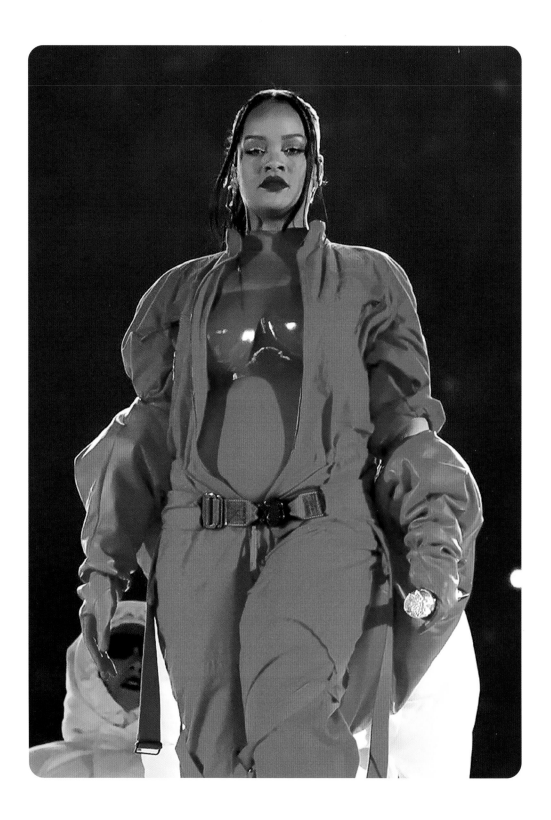

RIHANNA
and the clothes she wears

Terry Newman

ACC ART BOOKS

Introduction

Rihanna has learnt how to define her own terms, no matter what she does. Whether in the worlds of fashion, music, beauty, philanthropy, business, or activism, she is both muse and creative, a collaborator and pioneer. On a planet of protean role-models offering us post-truths, Rihanna's candour is compelling. She has over 135 million Instagram followers and counting. In 2022, at the age of 34, largely because of her Fenty Beauty empire, she became Forbes' youngest self-made billionaire. And BadGal isn't only a success on social media and in monetary terms, but in the real world. Her fans, 'The Navy', are intensely loyal. They get her and she gets them, declaring to *Glamour* magazine back in 2011: 'I don't look at [my fans] as followers under myself. We're peers. They're right here with me. I need them more than they need me. I need their feedback, I need their honesty, and I need their support. Without that, it's pointless. I respect them very, very much.' And they support Ri in everything she does. In 2017, Rihanna was the first female artist to top 2 billion streams on Apple Music. They buy her 'Gloss Bomb Universal Lip Luminizer' and they buy her 'Savage Not Sorry' string-thongs. But mostly they buy her attitude: her inclusive mindset and unapologetic approach to life. She told *The New York Times* in 2019: 'I will not back down from being a woman, from being black, from having an opinion.' Diversity is embedded in Ri's DNA. All the projects she invests time in enjoy an honest and fluid sensibility and this has translated into a hugely successful signature design manifesto – Savage X Fenty shows have cast amputees, trans-rights activists, pregnant women, and drag-queens as models. In a 2020 *i-D* magazine interview, size 14 super-model Paloma Elsesser, who walked for BadGal, explained the appeal: 'In general, being included in this beautiful tapestry that is Rih and her network is really incredible... To see dimpling on a thigh, and every shade, and every facet of what it means to identify as female. That experience was truly incredible – it was nuts.'

But it is Rihanna's personal wardrobe and the way she wears it that embodies her charisma, integrity and humour most. Everything she does reflects what she wears herself. She is a risk-taker, but as she said on the red-carpet in 2014, 'You will never be stylish if you don't take risks.' The gamble has paid off. Ri's mix-and-match method of wearing high fashion and streetwear, young designers, vintage hip-hop classics and avant-garde custom-made pieces has meant that she has equal footing in both the music and fashion industries. Chairman and CEO of the LVMH group, Sidney Toledano says she is 'a style icon for

'I grew up on a really small Island, and I didn't have a lot of access to fashion, but as far as I could remember, fashion has always been my defence mechanism. Even as a child I remember thinking, she can beat me, but she cannot beat my outfit. '

Rihanna, accepting the CFDA Fashion Icon of the Year Award in 2014.

today's generation' and the luxury conglomerate believed in her so much that in 2019, they backed Ri's Maison Fenty – the first Parisian fashion house launched by a Black woman. One of the world's highest-ranking influencers, Lisa, from the K-pop band BLACKPINK, who consistently pulls in the highest EMV (earned media value) for the brands she shows up for, told Korean *Elle*: 'My number one idol will always be Rihanna. She has everything I want to have.' And American *Vogue* doyenne, Anna Wintour, admitted on her YouTube Channel: 'I can never get enough of Rihanna's style.'

In 2005, Rihanna signed a six-album deal with Def Jam Recordings after auditioning for JAY-Z and L.A. Reid – singing her debut hit, 'Pon de Replay'. She was 16 and reportedly arrived at their offices wearing her first hairweave, white jeans and a blue tube top from Forever 21. Despite the synchronicity between her and the label, she revealed to the *Guardian*: 'When I first started, I didn't know anything, and I didn't really have a say. The second album, I got a little more freedom. That's when I found out what I wanted to do and be, but I still wasn't allowed to.' The key issue was how she looked: 'I felt like the whole world had long, curly, flowy blonde hair. Everybody wanted to be like everybody else. So, I cut my hair and they [Def Jam] made me put my long hair back in. The second time, I didn't have any discussions, nothing. I just cut it, I dyed it black, I went into the studio making music my way. I found myself all at once. I like things strong, edgy, a little to the left. I don't like things that are expected – nothing clichéd.' From then on Rihanna's fashion conviction grew. Adam Selman, the designer who created Ri's most famous outfit – the 'nude' dress, worn to the CFDA's in 2014 – said in a Style.com interview: 'She's daring, she's bold, and she's not afraid of fashion. She doesn't let fashion overcome her'.

Having laid down her own law when it comes to what she wears and when, Ri will gladly dress up in a sheer, Dior, baby-doll negligee while heavily pregnant, just because she feels like it. And not just that, she'll wear it front row at the Dior Show in Paris, like she did in March 2022 to the sound of the world's paparazzi flashbulbs and amongst the world's most cliquey fashionistas. Breaking maternity wear taboos is part of Rihanna's communication of identity. But again, it's not always as easy as Ri makes it look and the singer revealed to *ET*: 'I'm trying to enjoy it as much as I could, and fashion is one of my favorite things, so redefining what it even means to be pregnant and maternal... it can get uncomfortable at times so you can dress the part and pretend.'

Whether Rihanna decided to be a role model for women or not, her authority holds mega-wattage sway. Published a decade ago, *The Stage Hip-Hop Feminism Built: A New Directions Essay* (Durham, Aisha, et al) pinpointed a conundrum that Rihanna has helped deconstruct. They said then: 'Hip-hop feminists insist on living with contradictions, because failure to do so relegates

feminism to an academic project that is not politically sustainable beyond the ivory tower.' Today, what it means to be a feminist of any shape, size or colour is part of a developing and empowering conversation. Life is about defying stereotypical dogma – you no longer have to fit in a box. To many young women, it's an issue that's been simplified by Rihanna's career. She shows how it's possible to be a sexy, successful, Black, female singer in control of her image and identity. What she wears resonates not just because we love her in a Saint Laurent cape, a vintage Gaultier bustier or a pair of killer Manolos, but because she knows how to dismantle expectations of how they are traditionally supposed to be worn. BadGal has shown that trackies and heels, cut-off denim pants and couture, vintage and streetwear can look good together. She delights in breaking fashion rules and her dress choices have an impact beyond the fashion world. Her success sets an example for everyone, highlighting the importance of being true to yourself, whoever you are.

Rihanna has a faultless connoisseurship of fashion that is cool and original and the result of paying attention to what is out there and deciding for herself what she likes. From art school collections to streetwear drops from London, Paris, and Milan to New York and beyond, Rihanna knows what's going on in the fashion industry. Today, her brand is very much self-authored. She is in control of the creatives she surrounds herself with and the designers she wears. Long-term stylist, Jaheel Weaver told *Vogue* magazine in 2022 that 'Rihanna is just so fearless, so for me, it's always a question of "How do we make this look make sense for who she is?"'

Fans take for granted Rihanna's organic confidence with the clothes she wears, designs and inspires. They feel they know her well. However, Ri admits to being capricious, revealing in a 2017 *W* magazine interview: 'I enjoy new perspective. I get bored really easily, so I love when things can trigger an inspiration in my mind.' Her own icons have similar traits – Grace Jones, for example, who she fan-girled in a 2008 *Guardian* interview, saying 'She's just amazing. The things that she did, the things she wore, her fashion, from holding a cigarette to having a flat-top boy haircut. It took a really strong person to do that and as a female I look at her like: You. Are. Amazing.' All Ri's references, fashion-sense and characteristic career choices tend to dovetail towards a distinctive 'savage' disposition. In a 2018 *Vogue* interview, she talked about the meaning of 'Savage' and summed up her philosophy, saying it's 'really about taking complete ownership of how you feel and the choices you make. Basically, making sure everyone knows the ball's in your court.' And according to BadGal, the ball can be in your court whatever kind of woman you may be. As she told *Elle* magazine in 2019: 'It's important, right? You, me, trans women, women of all sizes, paraplegic women, all women are important women!'

Loving Saint Laurent

· ·

' Obsessed. '
—Rihanna, *Instagram*, March 2017.

In 2016, Hedi Slimane's final couture presentation for Saint Laurent was a glossy, haute kind of affair, dripping with lip-gloss. It was fashion trying its hardest to make a look-at-me declaration and be marvellous. While it could have been designed with Rihanna in mind, Slimane's show was actually inspired by Yves Saint Laurent's 1971 'Scandal' collection, which had caused a fashion commotion at the time. Yves had based his line on the clothes worn by women in France during World War II, and the '40s retro trend had seen his most influential muse, Paloma Picasso, buying boxy shoulder-pads and ankle-strapped platform shoes at vintage markets such as Portobello in London. Teamed with theatrical make-up, it was a style sensation. In Slimane's hands, the silhouette went viral. Rihanna picked up the most famous piece hot off the catwalk – the last look, a heart-shaped coat – and wore it out clubbing in NYC with a baseball cap, cut-off denim hot-pants and a signature pair of DSquared2 strappy heels. She mixed up the most statement piece of the most statement St Laurent collection with classic confidence. The singer is a

THIS PAGE: *The Saint Laurent Womenswear A/W 2016–17 show, Paris.*
OPPOSITE: *Rihanna in the Hedi Slimane heart coat, Manhattan, 5 September 2016.*

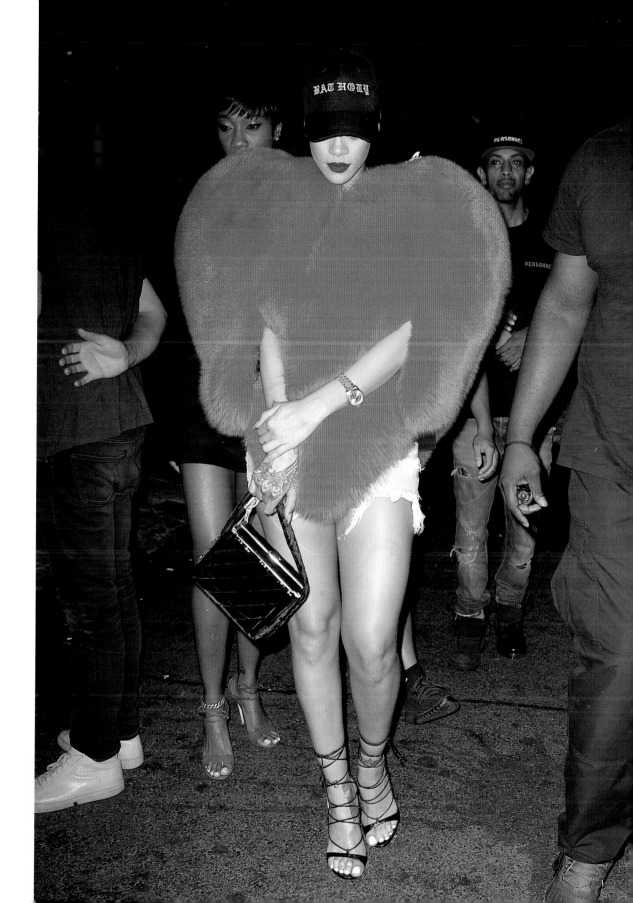

connoisseur of Saint Laurent and has also been seen busting a pair of collectible vintage shades. In February 2022, she re-wore the iconic red coat, making it modern again – this time teaming it with sweatpants by Vetements, the design house founded in 2014 by Demna Gvasalia and his brother Guram.

In 2019, for the launch of her first autobiography, RiRi's stylist, Jahleel Weaver, helped her choose another Saint Laurent outfit, this time designed by Anthony Vaccarello who took over as Creative Director after Slimane, and who had previously been artistic director at Versus, Versace. A suitably high-octane, asymmetrical, one-shouldered leopard-print dress, worn with python boots, spun a power-'80s story and showed off Rihanna's feline spirit. And she loves slouchy YSL boots – most notably the crystal-encrusted $10,000 pair featured in Vaccarello's S/S 2017 collection. BadGal showed us those boots were made for walking, wearing them out with ripped denim jeans and a black leather biker jacket.

OPPOSITE: *Rihanna in the Vaccarello leopard dress at her autobiography launch, Guggenheim Museum, NYC, 11 October 2019.*

Virgil, Louis V and RiRi

' You can
do it too. '
Virgil Abloh, *Instagram*, June 2018.

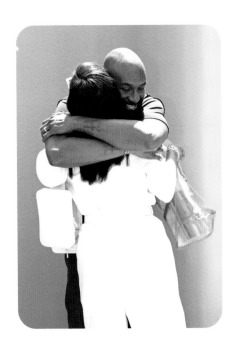

Virgil Abloh knew who to speed-dial when he was assembling the guest list for his June 2018 debut collection for Louis Vuitton in Paris. Rihanna was guest of honour and wore one of his soon-to-be-signature, oversized, unstructured, white suits to celebrate – an androgynous shape that Rihanna favours time and time again. Abloh would pass away just over three years later, having expanded the LV range and the meaning of luxury fashion – mixing up references and adding streetwear suave.

Abloh was not just a genius, he was kind, sharing and creatively supportive. And perhaps it's just a coincidence but when RiRi herself launched Fenty, an LVMH-backed brand of her own in May 2019, it would mirror in many ways some of the Abloh DNA shown at the Vuitton show, embracing inclusivity, hip-hop and a cooler-than-anything attitude.

THIS PAGE: *Designer Virgil Abloh and Rihanna hugging after the show.*
OPPOSITE: *Rihanna in a white LV jumpsuit at the Louis Vuitton Menswear S/S 2019 show, Paris, 21 June 2018.*

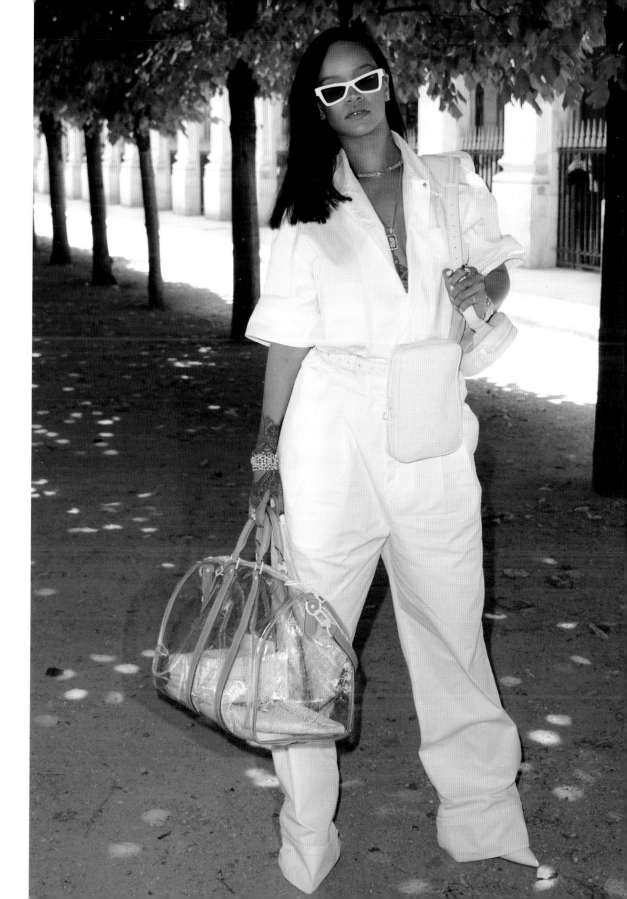

Comme Rihanna

> ' Best dressed,
> in my humble opinion was @rihanna #MetGala
> captured the spirit of the night
> & emotion of #Kawakubo #CommeDesGarcons. '
> —Lady Gaga, *Twitter*, May 2017.

When in 2017, the Met celebrated Japanese designer Rei Kawakubo, Rihanna chose to wear one of her most magnificent pieces in her honour. And 'pieces', rather than just mere 'clothes' they are – Kawakubo's label, Comme des Garçons is revered by fashion insiders as complex and pioneering. At her A/W 2016 collection, Kawakubo revealed it was about 'imagining punks in the 18th century, which was a time of so many revolutions'. For the opening of the 'Art of the In-Between' exhibition, Rihanna's CDG outfit was an insurgent fusion of floral jacquard and avant-garde flounce and, while its tiered, frayed petals were layered like a Stohrer pâtisserie, the frock itself felt like rebellious armour. Rihanna's styling of it added seditious sex-appeal too – something not usually associated with Kawakubo. BadGal wore the avant-garde designer's masterpiece with dancehall-queen energy and showed it off with her favoured DSquared2 lace-up-to-the-thigh red stiletto sandals that reportedly took an hour to tie.

THIS PAGE TOP: *Comme des Garçons A/W 2016–17 show, Paris, 5 March 2016.*
THIS PAGE BOTTOM: *Sex appeal BadGal style.*
OPPOSITE: *Rihanna in CDG at The Met Costume Institute Benefit Gala, NYC, 1 May 2017.*

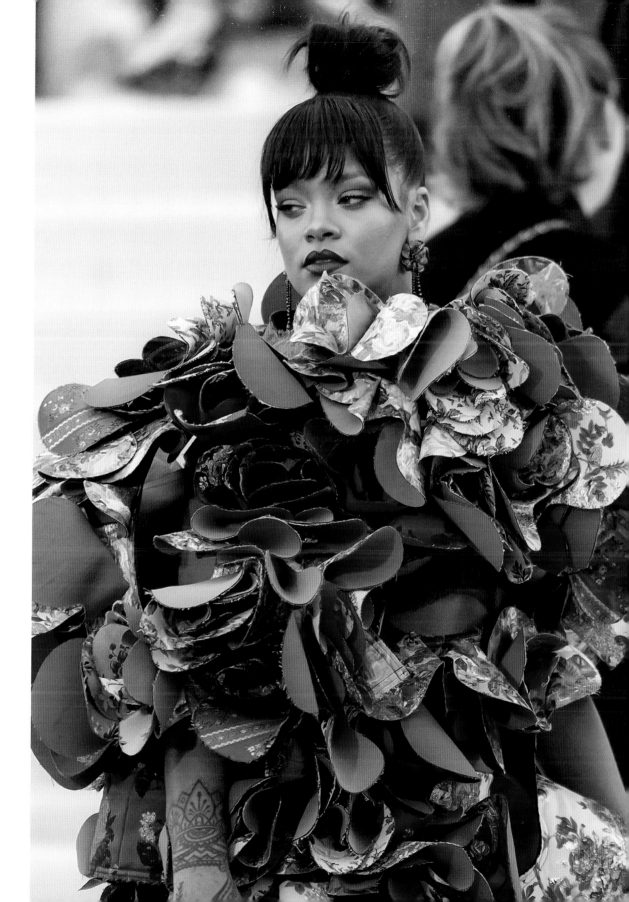

Dior Baby

· ·

' I think to be acknowledged
by Dior is just... it means a lot as a woman and to
feel beautiful, elegant and timeless.
It is such a big deal for me, for my culture,
for a lot of young girls of any colour. '
—Rihanna, *MTV interview*, March 2015.

When Rihanna arrived late for the Dior Show in March 2022, she was heckled for it. Her timeless response – 'No shit!' – went viral. The reality is that the world – including Dior – will always wait for Rihanna. Pregnant at the time, she looked regal in a black, baby-doll, Dior dress, which her stylist, Jaheel Weaver had taken the lining out of, making it sheer and showing off both her Fenty G-string and her baby-bump. Maria Grazia Chiuri – the House's current artistic director, beamed her approval of the outfit during the photocall afterwards. Rihanna and Dior go way back: she became their first ever Black ambassador while Raf Simons was still at the helm in 2015 and she was the first to collaborate on a sunglasses range, which debuted in 2016. The shades were inspired by Starfleet Enterprise Officer, Geordi La Forge, played by LeVar Burton – a characteristically confident reference that evidences the orbit of RiRi's pop-cultural scope.

THIS PAGE: *Maria Grazia Chiuri's Christian Dior S/S 2017 show, Paris, 30 September 2016.*
OPPOSITE: *Rihanna, shows off her baby bump after the Dior A/W 2022–23 show during Paris Fashion Week, 1 March 2022.*

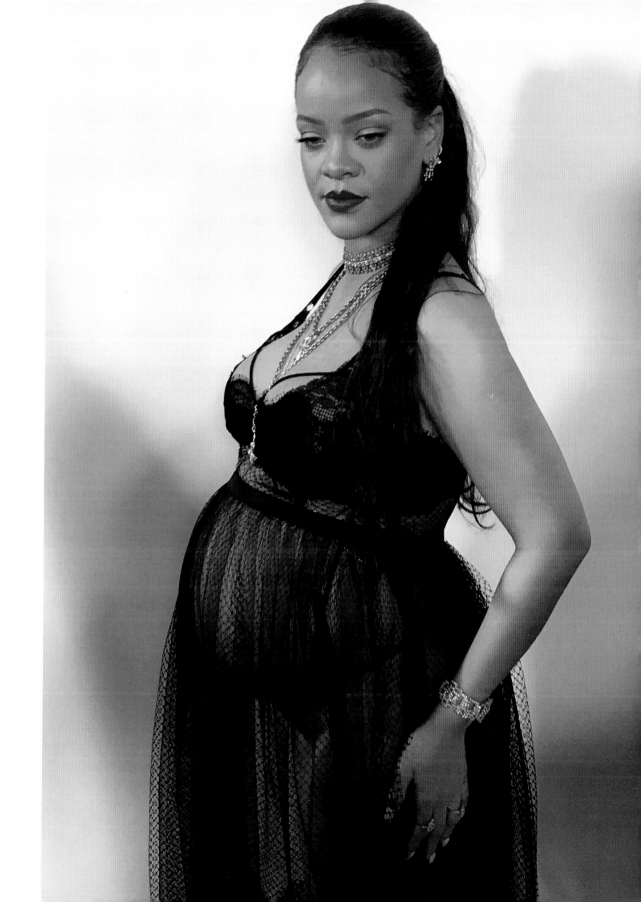

Starring in Dior's 2015 'Secret Garden IV' campaign film, shot by Steven Klein at Versailles, BadGal personified Dior's glamour and luxury, making it feel modern, relevant, and aspirational: exactly the impression Sidney Toledano, Dior's CEO at the time, knew was gold-dust. He declared: '[She] is a goddess but accessible. The way she moves is part of the young generation.' But Rihanna's relationship with the House is about more than just glamour. When Maria Grazia Chiuri's first collection for Dior hit the runway in March 2017, a portion of the profits from the sale of her We Should All be Feminists T-shirts – an homage to Chimamanda Ngozi Adichie's essay – went to RiRi's Clara Lionel Foundation. The designer remarked at the time: 'Seeing artists such as Rihanna wearing the We Should All Be Feminists T-shirt showed me how important it is for women to advance their fight.'

OPPOSITE: *Rihanna at the Christian Dior A/W 2017–18 women's ready-to-wear collection, 3 March 2017.*

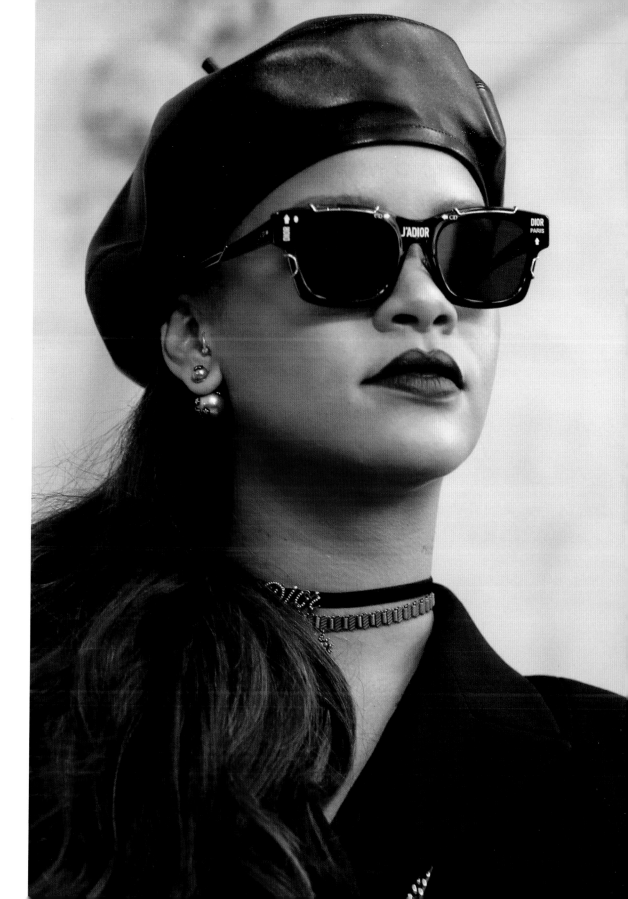

Coco-Loco

‘ It was wonderful,
I had an incredible experience.
I saw a lot of beautiful, beatiful things
I would love to wear. ’

—Rihanna, *Elle Podcast*, July 2013, discussing the A/W 2013–14 Chanel Couture show.

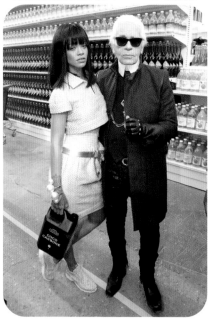

When Karl Lagerfeld died in 2019, Rihanna used her Instagram to let her 135 million followers know exactly how she felt, referring to him as 'The Godfather'. Lagerfeld, with his finger on the creative pulse 24/7, understood Rihanna was extraordinary, and so BadGal became a front–row fixture at his shows. Rihanna has a colossal comprehension of the codes of Chanel – she wears it casually, like Coco herself would have wanted. The fashion house was originally about womenswear that felt effortlessly chic, accessorising it with luxe bling. Coco Chanel made clothes for women to feel comfortable in. It's this legacy that Karl picked up and ran with while he was artistic director, connecting the 100+ year–old fashion house with the contemporary world; making it easy, fun and sexy. In January 2022, when Rihanna chose to announce to the world that she was expecting a child, she did so wearing a hot–pink vintage Chanel puffer coat from Karl's A/W 1996 collection teamed with pale denim jeans and a Chanel chain belt. The Godfather would, no doubt, have approved.

THIS PAGE TOP: *Rihanna in poppy Chanel Shades, NYC, April 2013.*
THIS PAGE BOTTOM: *Rihanna and Karl, Paris, 4 March 2014.*
OPPOSITE: *Rihanna in Chanel costume jewellery at the Chanel pret–a-porter S/S 2010 show, Grand Palais, Paris, October 2009*

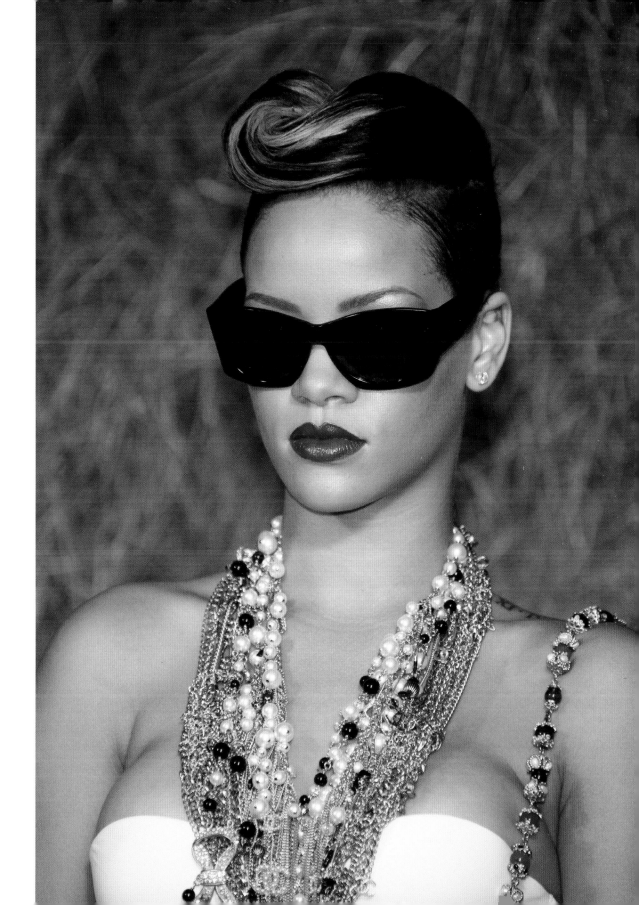

Check it Out

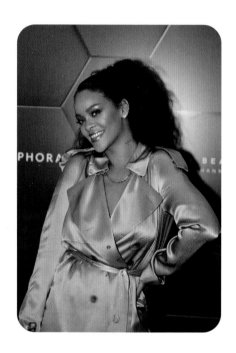

The English heritage brand Burberry is a firm fashion success story. Its craftsmanship and traditional silhouettes have been famously re-invented and its signature Haymarket tartan–check, created in 1924, still holds sway. Riccardo Tisci – artistic director from 2018–22 – is an old friend of Rihanna's. And Rihanna is a big friend of Burberry's – their famous trench-coat is a favoured piece, and she has made it her own, often wearing it as a dress. In fact, the trench–as–a–dress was her chosen outfit when she presented her first Fenty Beauty demonstration in Dubai in September 2018. Selected from Tisci's Burberry spring 2019 catwalk show, the coat – made from gold–coloured silk – was an immediate classic.

There is nothing past tense about Rihanna's styling, and for the March 2020 *Vogue* cover she again chose Burberry, this time teamed with a durag designed by milliner Stephen Jones. That's not to say she isn't a fan of the conventional check though – in 2017 she stepped out in vintage Haymarket trench and cap, busting Burberry's legacy look very nicely.

THIS PAGE: *Rihanna in silk Burberry during her Fenty Beauty talk for the launch of her new Stunna Lip paint "Uninvited", Dubai, 29 September 2018.*
OPPOSITE: *Rihanna in Burberry hat and mac at the SZA Concert at The Box, NYC, 10 October 2017.*

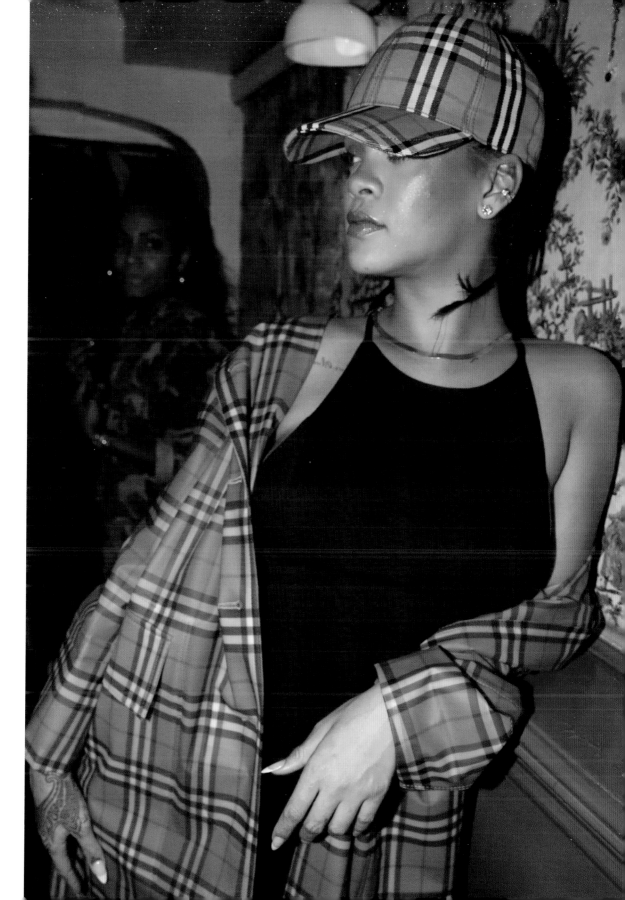

Loveee

- -

'She can throw on combinations
you can't imagine other people could possibly wear
and look great. '
—Tom Ford, *Vogue*, March 2020.

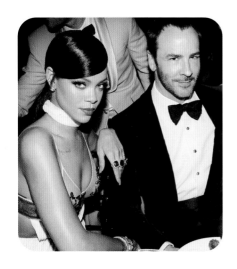

The love affair between Rihanna and Tom Ford is an open secret. Mutual adoration abounds between the two. Ford famously went to work at Gucci in 1990 and Saint Laurent in 1999. His designs infused the '90s with a sensual edge. His silk 'dollar-green' slip dresses, low-slung velvet boot-cut pantsuits and slashed-to-the-waist satin shirts gave the fashion industry an alternative to grunge and minimalism. His clothes back in the day were about money and sex and, having launched his own line in 2004, Ford continues today to create the most jaw-dropping collections. So, when a designer of his calibre shoots love-hearts out, it's good to take notice.

His love for RiRi is unconditional. In March 2014 at the CFDA Awards, Rihanna presented Ford with a Lifetime Achievement Award – while wearing another designer's dress. Not awkward at all... Tom said afterwards: 'I have to say that Rihanna was for me, that night, one of the most beautiful women that I have ever beheld. I had designed several things

THIS PAGE: *Rihanna and Tom Ford at the amfAR LA Inspiration Gala, Hollywood, 29 October 2014.*
OPPOSITE: *Rihanna in Tom Ford glamour, backstage at Milk Studios, Hollywood.*

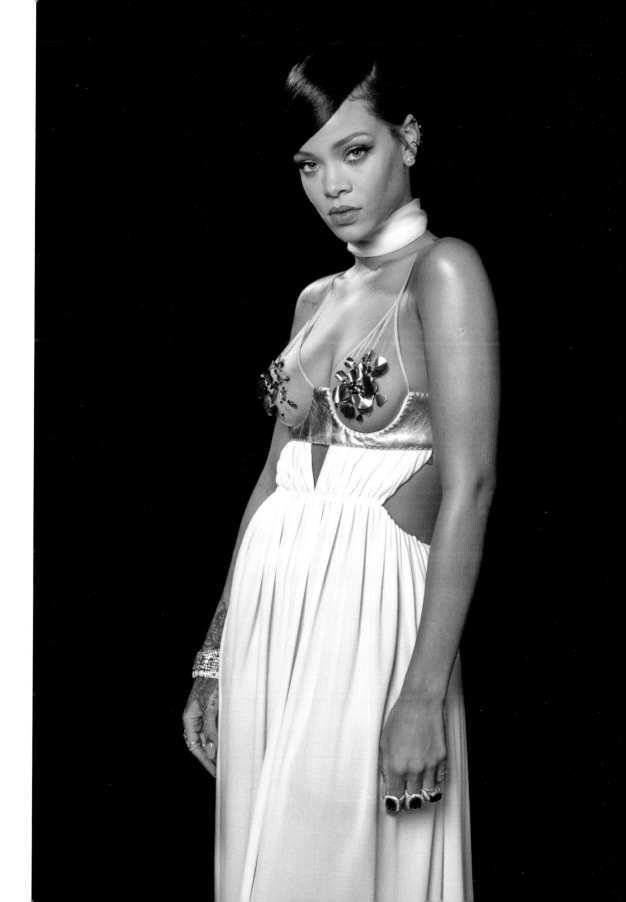

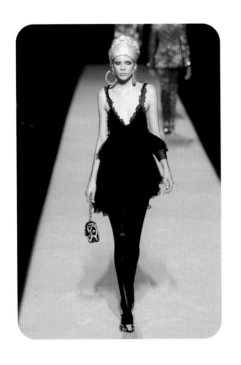

for her specifically for that evening which she did not wear, but when I saw her, it did not matter. I whispered into her ear that she was right not to have worn one of my dresses that night because she looked more beautiful than I have ever seen her look. She was stunning.'

The love is mutual, and notwithstanding that infamous evening, Rihanna is a committed Ford follower. For the amfAR Inspiration Gala in 2014, she wore a floor-length Grecian Goddess gown with a sheer bra-top adorned with purple floral pasties. For the prestigious Vogue Forces of Fashion 125th anniversary conference held in October 2017, she selected a triple denim outfit from his S/S 2018 show. Surprisingly, at the Fenty X Savage lingerie launch in May 2018, one of the biggest events of her career, she didn't go for a total look: she picked a Tom Ford black baby-doll dress with Manolo stilettos and her own open-cup bra and stockings. It fit right in with her 'bad-bitch' brand philosophy.

THIS PAGE: *Tom Ford Womenswear A/W 2018 Collection, Park Avenue Armory, NYC, 8 February 2018.*
OPPOSITE: *Rihanna wearing A/W 2018 Tom Ford at Fenty X Savage lingerie launch, NYC, May 2018.*

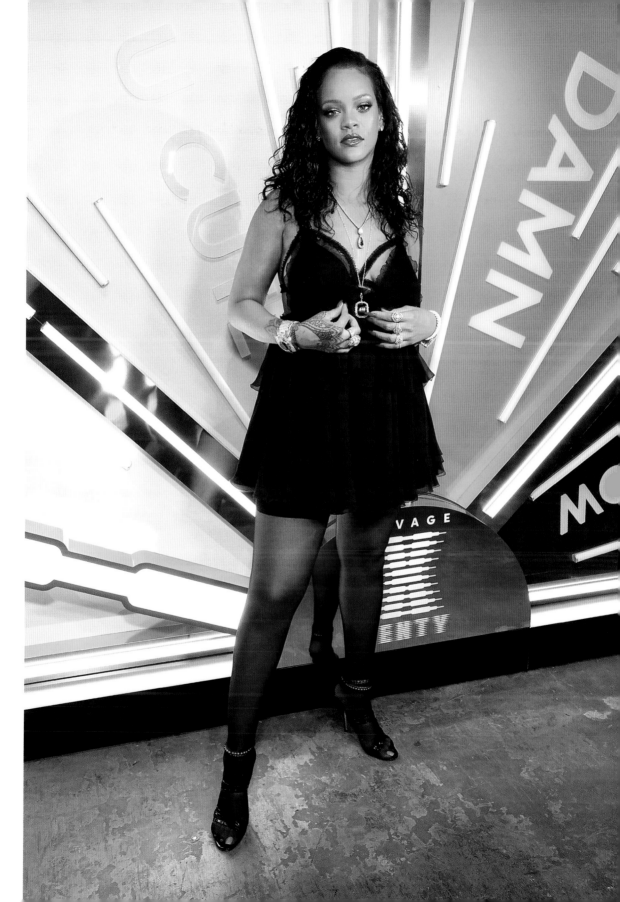

Rihanna X Black Lives Matter

When George Floyd was killed in Minneapolis on 25 May 2020, civil rights attorney Ben Crump released a family statement shortly after: 'The pain that the black community feels over this murder and what it reflects about the treatment of black people in America is raw and is spilling out onto streets across America.' But it wasn't just Americans who reacted to the homicide: millions of people around the world began to protest in solidarity. Despite the Coronavirus pandemic locking down most countries, the streets began to fill with demonstrations, defying restrictions. The internet united communities and they began to react in all ways possible.

Rihanna's speech at the NAACP Image Awards in February of that year, where she spoke about 'the Michael Brown Juniors and Atatiana Jeffersons of the world', had been a presentiment of what was about to shatter the Floyd families' lives. She was there to accept The President's Award from Derek Johnson for her ongoing philanthropic work and rose to the distinguished honour by wearing a purple couture gown from Givenchy's spring 2020 collection, designed by the artistic director at the time, Claire Waight Keller.

OPPOSITE: *Backstage at the 51st NAACP Image Awards, February 2020.*

When the Black Lives Matter Movement, founded in 2013, galvanised internationally over the Floyd murder, the fashion world stepped up and Rihanna, as one of the most high-profile Black designers and artists, naturally supported the cause – she was on the team already, having joined Beyoncé and Pharrell in a 2016 BLM music video named: '23 Ways You Could be Killed If You Are Black in America'. But on 2 June, 2020 – Blackout Tuesday – it was her fashion empire that did the talking. All her Fenty labels shut down and she announced on her Instagram: 'we ain't buying shit!!! and we ain't selling shit neither!! gang gang! #BLACKOUTTUESDAY AF!!! @fenty @fentybeauty @savagexfenty 🤟🏾🤟🏾🤟🏾'.

Later that month, Rihanna's Clara Lionel Foundation went further and revealed on their Twitter account that 'Together with #startsmall we have distributed $11 million in grants to groups fighting for racial justice, police reform, equitable justice systems, decreasing criminalization and building local power.' Her activism is important because it inspires. In October 2019, BadGal posted a video of herself wearing an exclusive pink tie-dye dress by ASAI, attracting over 24 million views on Insta. On 30 May, 2020, the Chinese Vietnamese British ASAI founder and designer, A Sai Ta, took to his own Instagram to announce that he was remaking the exclusive dress for a special charity initiative. He declared: 'NO [ONE]

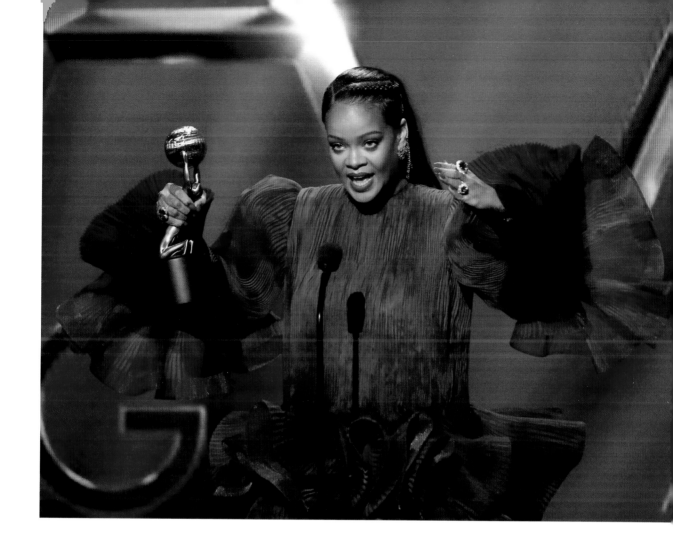

ELSE HAS THIS DRESS APART FROM ME AND RIRI :)
FINALLY YOU CAN ALSO HAVE THIS DRESS AND THE
ONLY WAY !! #ALL PROFITS FROM THE SALE OF THE
@badgalriri HOTWOKDRESSESWILLBEFOR @blklivesmatter
@solacewomensaid @thevoiceofdomesticworkers 🤍🤍🤍,

THIS PAGE: *Accepting the President's Award.*
OPPOSITE: *Asai, Arise Fashion Week, Lagos, Nigeria, 21 April 2019.*

'If there's anything that I've learned, it's that we can only fix this world together... We can't let the de–sensitivity seep in: 'If it's your problem, it's not mine. It's a woman's problem. It's a black–people problem. It's a poor–people problem. So, when we're marching, protesting and posting about the Michael Brown Juniors and Atatiana Jeffersons of the world, tell your friends to pull up... Imagine what we could do together. '

Rihanna, NAACP Image Awards,
22 February 2020.

'The fight against racial inequality, injustice, and straight–up racism doesn't stop with financial donations and words of support. In solidarity with the Black community, our employees, our friends, our families, and our colleagues across industries, we are proud to take part in #BlackoutTuesday. '

Fenty/Fenty Beauty/Fenty X Savage websites, 2 June 2020.

New-Skool

- -

One of the most high-profile legacy projects Rihanna has been involved in was an effort to help a quarter of a billion children, supporting them with educational opportunities. Rihanna joined the Global Partnership for Education as an ambassador in 2016 and worked unfailingly for this cause, travelling to Malawi and Senegal to see for herself what needed to be done. She said in 2017: 'When it comes to helping the world's poorest children, as well as the communities and societies in which they live, I'm still learning – and I need others to join me on the journey and use their voices alongside mine.' An exchange with Angela Merkel's spokesperson after the Malawi trip was typical of RiRi's proactive attitude: 'Germany, I'm checking in to see where we are on the commitment to #FundEducation w/ @GPforEducation? @regsprecher, I'm depending on you!' 'Germany' quickly tweeted back: 'Hi @Rihanna, education is a key area of German development policy. We have nearly doubled spending since 2013.'

OPPOSITE: *Rihanna attends the GPE Financing Conference in Dakar, Senegal, February 2018.*

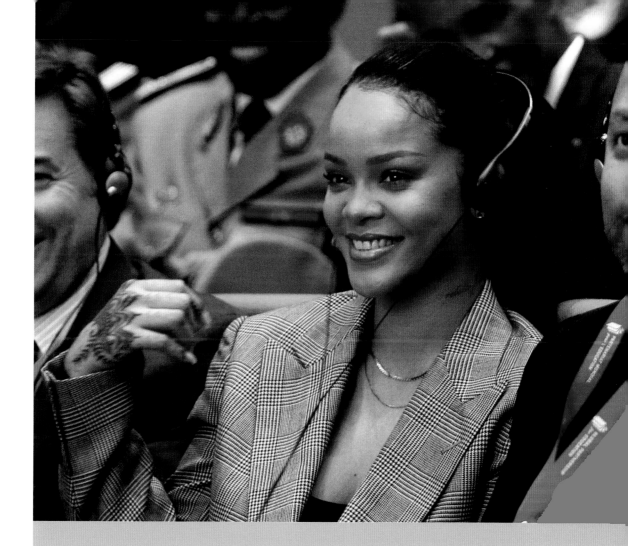

‘ I feel strongly that all children everywhere should be afforded the opportunity of a quality education. Therefore, I'm proud to announce Clara Lionel Foundation's partnership with education advocacy leaders like the Global Partnership for Education and Global Citizen. Working together, I know we can amplify our efforts and ensure that millions of children gain access to education globally. ’

— Rihanna, September 2016, GPE press release.

In July 2017, wearing a super-sized Dior jacket, she called in on Emmanuel and Brigitte Macron at their place in Paris and got them on board, later tweeting: 'Thank you Mr. President @EmmanuelMacron and Madame First Lady for the incredible meeting and passion for global and girls' education!' The next year they hooked up again in Dakar, where the French and Senegalese presidents co-hosted a Global Partnership for Education conference. Sticking to business-wear BadGal dressed in an A/W 2017 double-breasted Ralph Lauren Prince of Wales check suit and carried a Dior Addict bag.

OPPOSITE: *Rihanna meets Brigitte Macron at Elysée Palace, July 2017.*

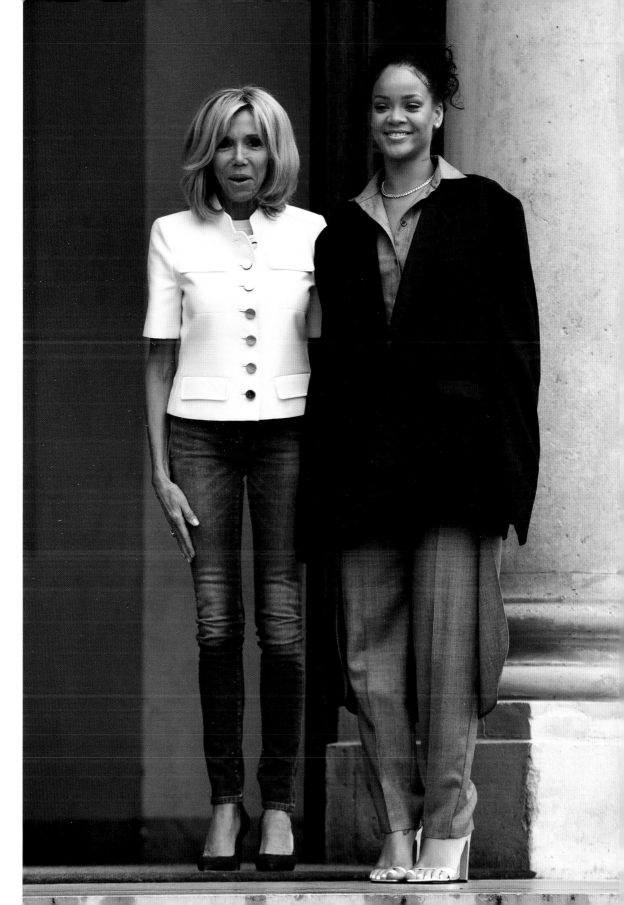

RiRi the Right Excellent

In 2021, after almost 400 years, Barbados became a republic. The incoming president, Dame Sandra Mason, declared: 'The time has come to fully leave our colonial past behind.' At the same ceremony, Rihanna was inaugurated as the 11th National Hero. It was clearly a moment for change. Rihanna became the youngest person, and only the second woman, to have the distinction conferred on her. She wore a piece from Daniel Lee's final collection for Bottega Veneta – a Resort 2022 orange satin halter-neck dress. The day was a celebration, and in true Rihanna style, she selected her outfit carefully for the Independence Day Parade, choosing a white skirt suit by young UK designer, Maximilian Davis. Davis' work is very much about identity, and he explained to Highsnobiety: 'England is where I was born and where I grew up, but it's not what made me who I am today. It's not my culture. My identity is Trinidadian–Jamaican. Never forget where you started.' It's a sentiment clearly shared by RiRi, who said about her new title: 'What an absolute honor to be amongst such great men and women who have come before me and held this title in commitment to our nation! I will cherish these memories and continue to represent the Bajan people and my home Barbados to the fullest!!'

OPPOSITE: *Onstage with Prime Minister Mia Mottley and President Sandra Mason, Heroes Square in Bridgetown, November 2021.*

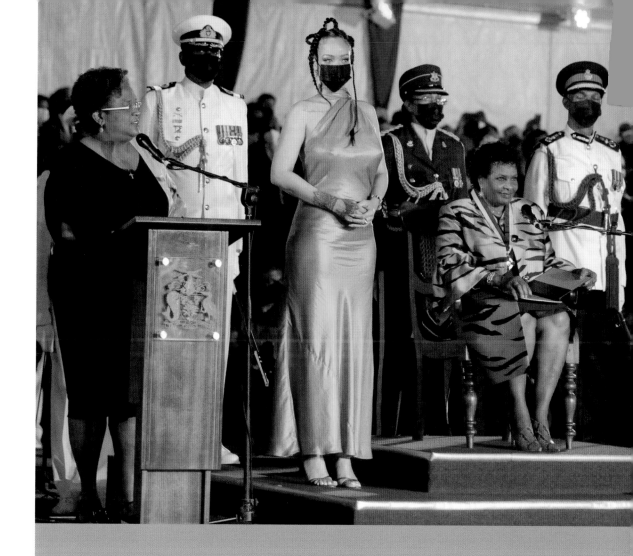

‘ May you continue to
shine like a diamond
and continue to bring honor to your
nation by your words, by your actions, and to do
credit wherever you shall go. ’
— Prime Minister Mia Mottley to Rihanna at the
National Heroes of Barbados ceremony, November 2021.

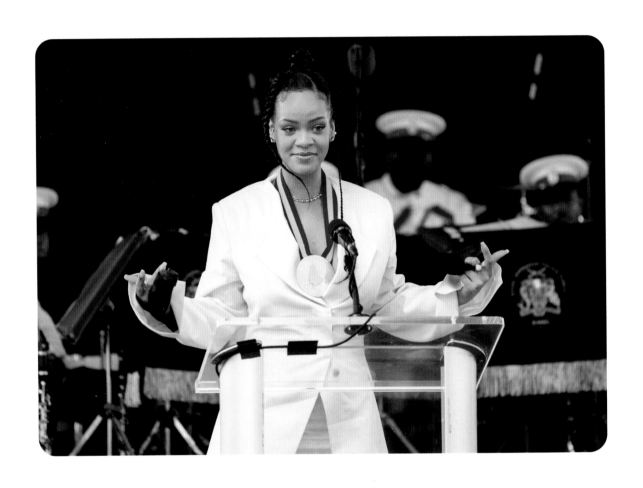

THIS PAGE AND OPPOSITE: *Ri becomes the 11th National Hero of Barbados.*

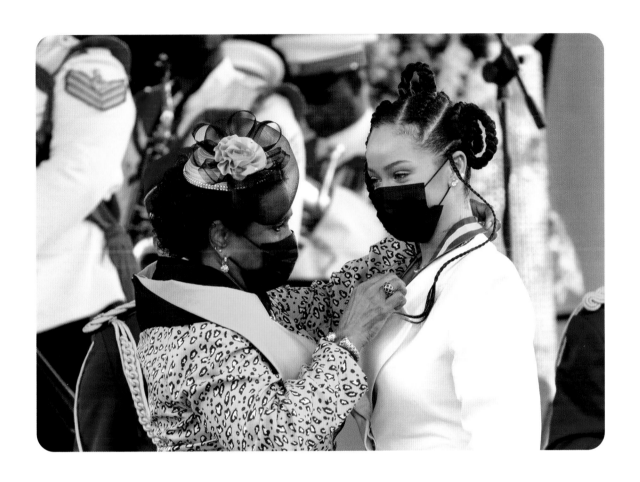

Respect for Ri

Harvard University give their Humanitarian Award to people who have 'inspired us to higher heights'. Past recipients have included civil rights activist Martin Luther King, UN Secretary General Ban Ki-moon and the Nobel Peace Prize winner and female education activist, Malala Yousafzai. In 2017, they decided to give the honour to Rihanna. 'Rihanna has charitably built a state-of-the-art center for oncology and nuclear medicine to diagnose and treat breast cancer at the Queen Elizabeth Hospital in Bridgetown, Barbados', explained Harvard's director. With this and her Clara Lionel Scholarship for Caribbean students aiming for US Colleges, plus her work with The Global Partnership for Education, her philanthropy has had a significant impact and was duly recognised by the most prestigious academic institution.

Her speech at the ceremony revealed her incredulity: 'So I made it to Harvard. Never thought I'd be able to say that in my life, but it feels good.'

OPPOSITE: *Rihanna receives her Harvard Humanitarian of the Year Award, February 2017.*

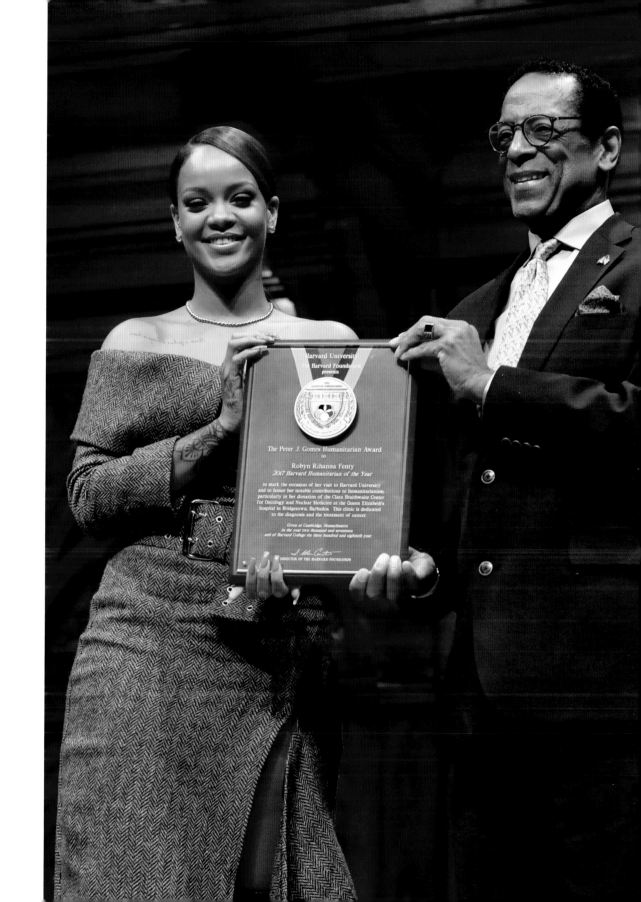

Rihanna received the award wearing an autumn 2017 Monse outfit, the NYC-based label designed by Fernando Garcia and Laura Kim, who also work as the co-Creative Directors of Oscar de La Renta. In tune with the day's proceedings, RiRi's traditional Herringbone tweed ensemble mixed conservative elements with an avant-garde twist. Her wide, off-the-shoulder, cowlneck, long-sleeved, slit-skirt dress was expertly cut and worn with pair of co-ordinating herringbone stilettoed boots. The strong look, in such time-honoured fabric, fused RiRi's edgy modernity with the backdrop of America's oldest university. Style we can all learn from.

OPPOSITE: *BadGal makes a point.*

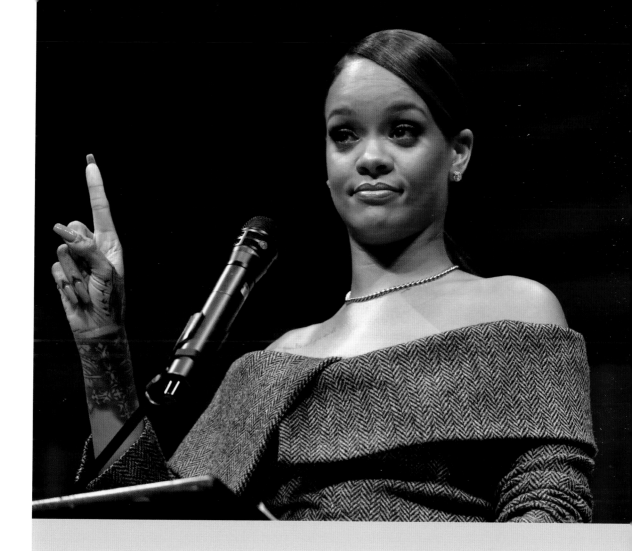

'I would think to myself, "I wonder how many
25 cents I could save up to save all the kids in Africa."
And I would say to myself,
"When I grow up and I get rich,
I'm gonna save kids all over the world."
I just didn't know I would be in a position
to do that by the time I was a teenager. '
— Rihanna, Harvard University, February 2017.

Diamond Nights

· ·

> ' There's no doubt that Rihanna is a global brand, but **more than anything she's a global agent of change.** She hasn't rested on her music or her entrepreneurship. **She's using it as a force for good.** '
> — Prime Minister Mottley, *time.com*, September 2019.

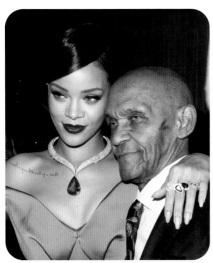

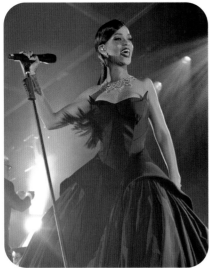

The Clara Lionel Foundation Rihanna founded in 2012 is a nucleus of initiatives that supports emergency relief and charities, with incisive, targeted action. Named after RiRi's grandparents, Clara and Lionel Braithwaite, it has raised money for issues including climate change, women's education, natural disasters, and cancer care, and donated substantial amounts of money to many causes. The foundation's sparkling Diamond Ball was an anticipated event in every A–lister's diary right from the get–go. The first, held in December 2014 at the Vineyard in Beverley Hills, saw RiRi supported by friends, including Salma Hayek and Kim Kardashian, as well as special guest, Big Sean. BadGal wore two different Zac Posen dresses, starting the evening in a rose satin floor–length, accessorised with a stunning Chopard rubellite and diamond necklace, before changing into a navy silk strapless gown with a full skirt to sing on stage later in the evening. The Ball was a yearly affair, each event becoming a more and more fashionable pilgrimage, until the pandemic shut down socialising. Rihanna's highlights

THIS PAGE TOP: *Rihanna with her grandfather, Lionel at the First Annual Diamond Ball benefitting The Clara Lionel Foundation, The Vineyard in Beverly Hills, 11 December 2014.*
THIS PAGE BOTTOM: *Quick change, 2014.*
OPPOSITE: *All smiles in Posen satin and Chopard diamonds, 2014.*

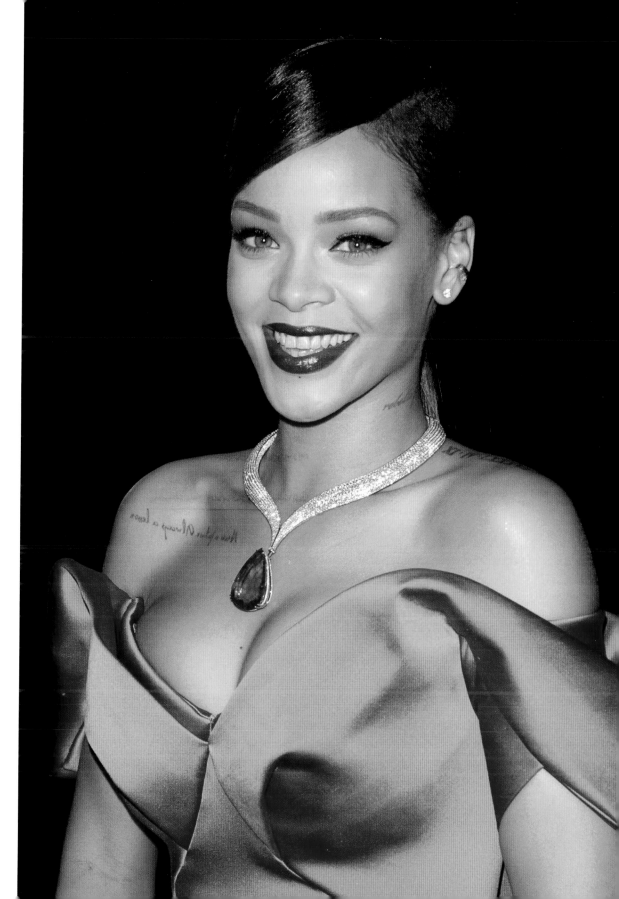

included fits by Dior, Ralph and Russo, and Alexis Mabille. The most recent took place the day after RiRi's spectacular Fenty New York Fashion Week 2019 show and saw her take it to couture heights – she chose a velvet, high–necked, full–boned, mermaid–skirted, autumn Givenchy piece by Clare Waight Keller to wear. Again, she performed – this time with Pharrell – and shortly afterwards, the stage was stampeded by 2 Chainz, A$AP, DJ Khaled, and Fat Joe, amongst many other members of rap royalty eager to join in and keep the party moving.

OPPOSITE: *RiRi at the 5th Annual Diamond Ball, 12 September 2019.*

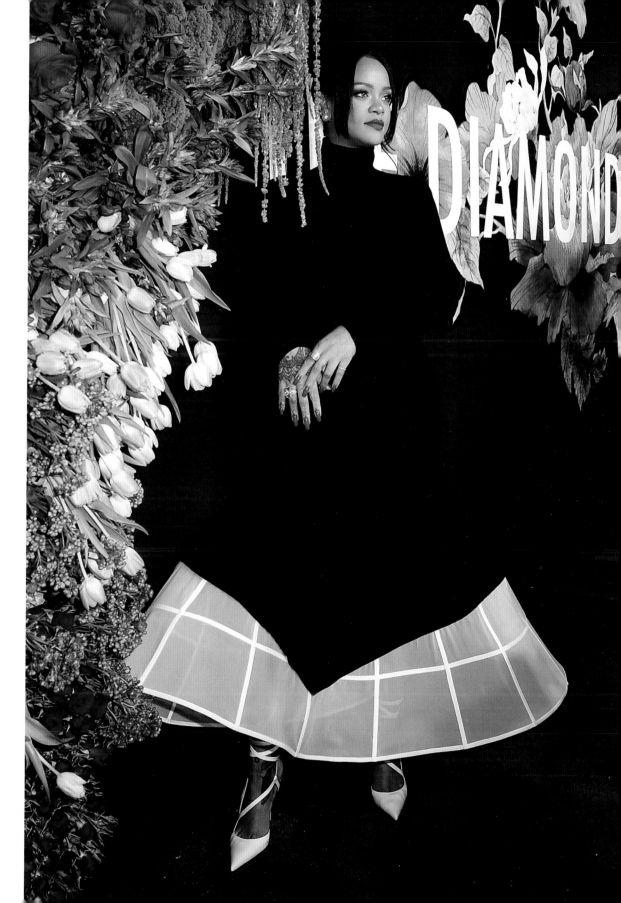

Dripping at the Met Gala

The first Monday in May has been a date to keep for the world's most fashionable since 1948 when the PR supremo, Eleanor Lambert, inaugurated the Met Gala as a fundraiser for the Metropolitan Museum of Art. In its history, the Gala has only ever skipped 3 years – including in 2020 because of the pandemic.

The 2021 event bounced back, switching to September for one time only; it was also one to remember for Rihanna, who wore a Balenciaga coatdress by Georgian designer, Demna Gvasalia. The theme was 'In America: A Lexicon of Fashion' and when questioned on how her look fit with the theme, RiRi retorted: 'I'm an immigrant and that's my take on American fashion.' She went on to explain to *Essence* magazine: 'Well, I wanted a look that seemed very powerful, yet feminine, yet a black hoodie which is the thing that we're usually incriminated by as Black people... I wanted to empower that and take it and make it mine and make it fashion.'

OPPOSITE: *The American Dream, 2021.*

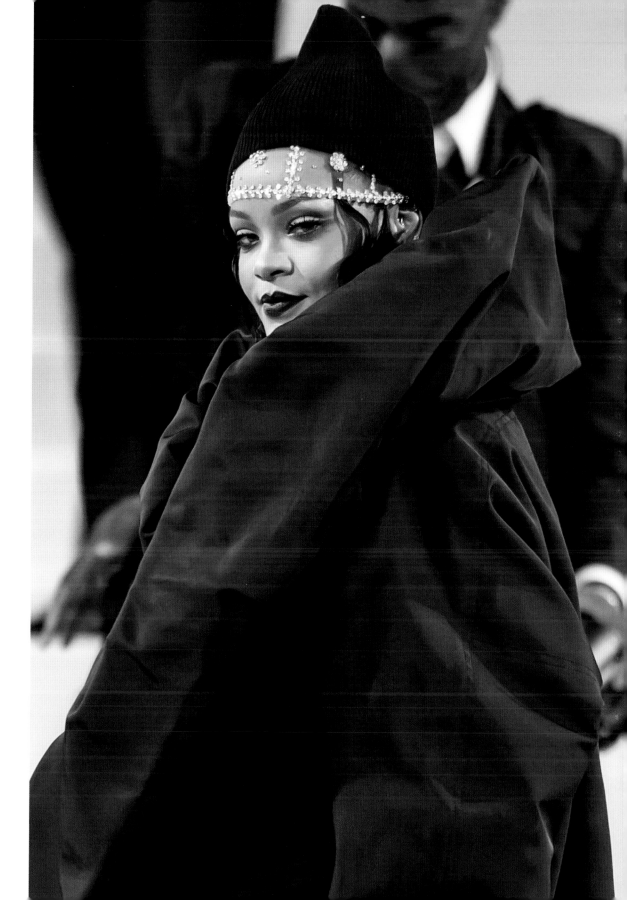

Rihanna has been gracing the Met carpet since she was just 19 years old. Her first, in 2007, was themed 'Poiret: King of Fashion' and she wore a white evening dress by Lebanese designer Georges Chakra. Even then, RiRi was beginning to deconstruct fashion, wearing the romantic frock with a pair of black fishnet gloves and carrying a single red rose as an accessory.

Becoming a fashion goddess takes work and nerve when the world is watching you. In 2015, she shut down the Internet wearing Chinese designer Guo Pei's 'Yellow Empress gown' made from gold thread and featuring a 16ft train. She told *Access Hollywood*: 'I remember being so scared to get out of that car because I felt like, "I'm doing too much". I was driving past the red carpet, and I was just seeing, like, gowns, and I was like, "Oh my god, I'm a clown. People are going to laugh at me"'. She co-hosted in 2018 with Donatella Versace, and George and Amal Clooney. For the 'Heavenly Bodies: Fashion and the Catholic Imagination' theme she wore a

OPPOSITE: *19-year-old Ri wearing Georges Chakra, 2007.*

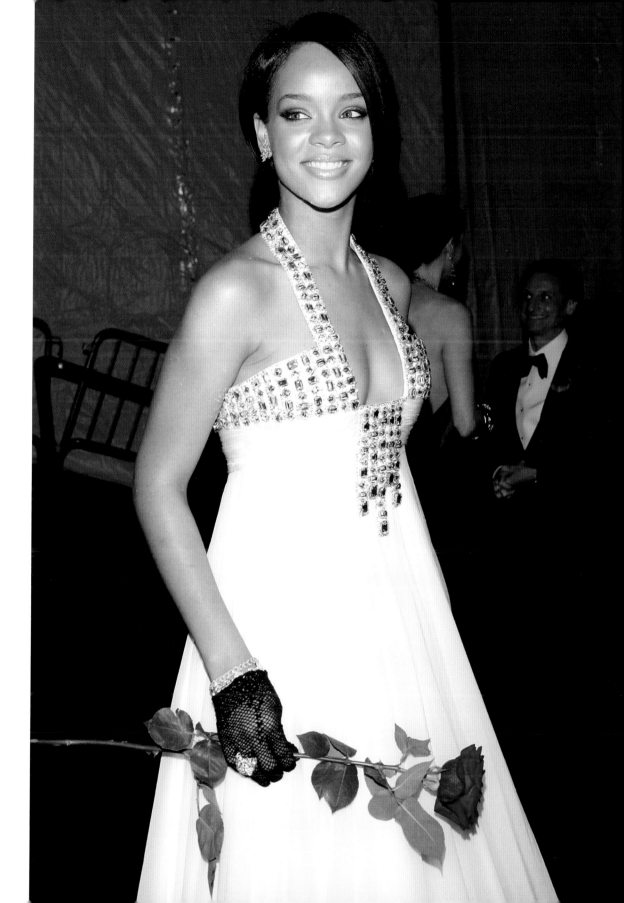

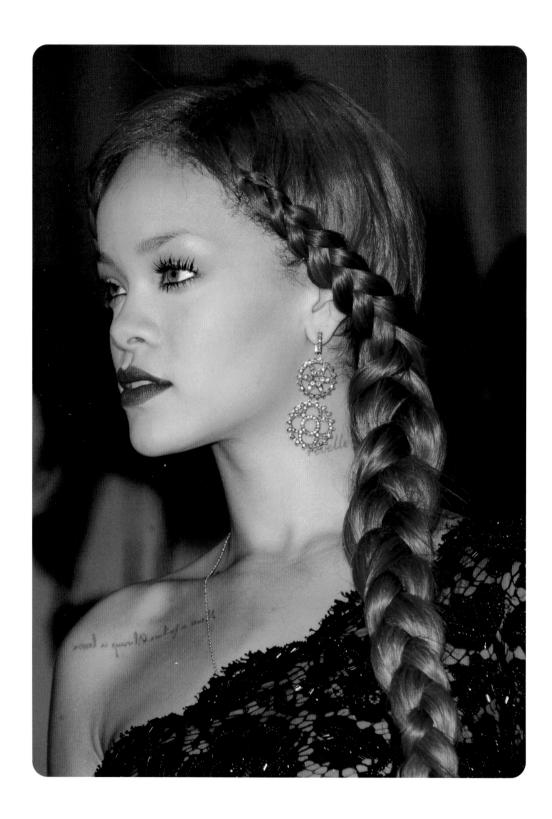

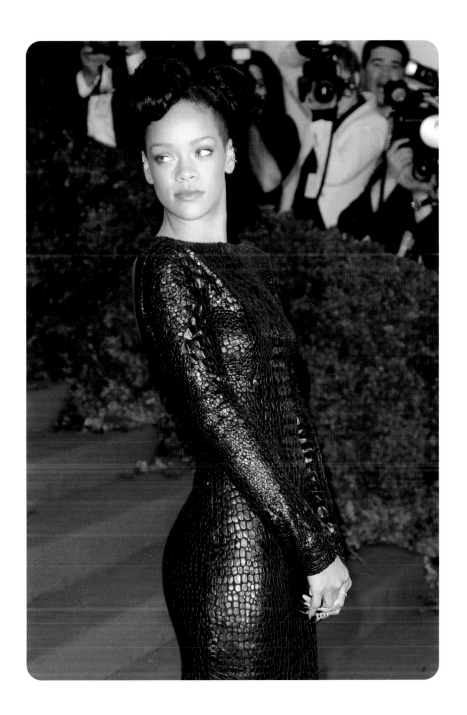

PREVIOUS PAGE: *Slick in a Dolce & Gabbana tux, 2009.*

THIS PAGE: *Stunning in assymetric lace by Stella McCartney, 2011.*

OPPOSITE: *Slinky in Tom Ford, 2012.*

hand–beaded Maison Martin Margiela Artisanal dress robe and papal mitre designed by John Galliano. 'It would be a sin not to wear it', she told *Vogue* magazine.

In an episode of *Go Ask Anna*, Anna Wintour, explained how seriously RiRi takes her fashion, revealing that BadGal had worked with Galliano to create three gown options in red, cream, and black. The outfit seemed impossible to top, but in 2022, Rihanna's look became art – literally. Pregnant BadGal couldn't go to the Gala, so instead, The Met created a CGI statue of her May issue *Vogue* cover, shot by Annie Leibowitz, in which Rihanna wore an orange bodysuit and gloves by Azzedine Alaïa.

OPPOSITE: *Regal in Guo Pei for 'China: Through the Looking Glass', 2015.*
FOLLOWING PAGE: *'Heavenly Bodies: Fashion & the Catholic Imagination', 2018.*

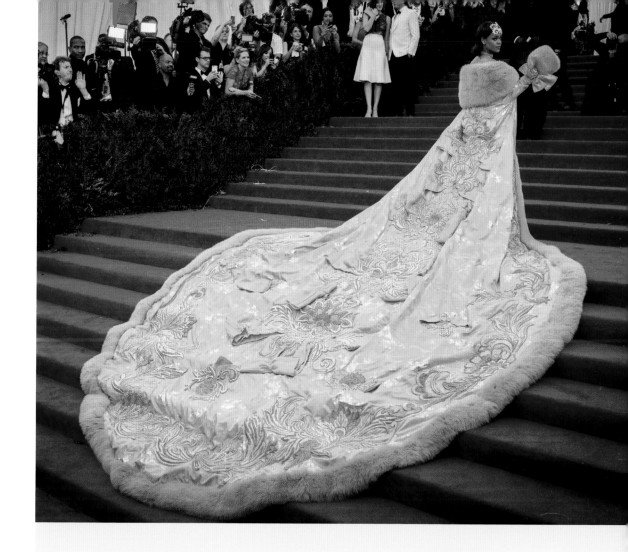

'You wore that amazing outfit which means that the
world will never look at yellow
in the same way again
after I guess it was
one billion impressions, two billion
impressions, and counting. '
— Anna Wintour, *Go Ask Anna*, September 2019.

'Shut down the Met in marble!
What's more gilded
than that? Lol!
Thank you @metmuseum
and @voguemagazine for this
historic tribute!
Y'all bad for this one! '

Rihanna, *Twitter*, 3 May 2022.

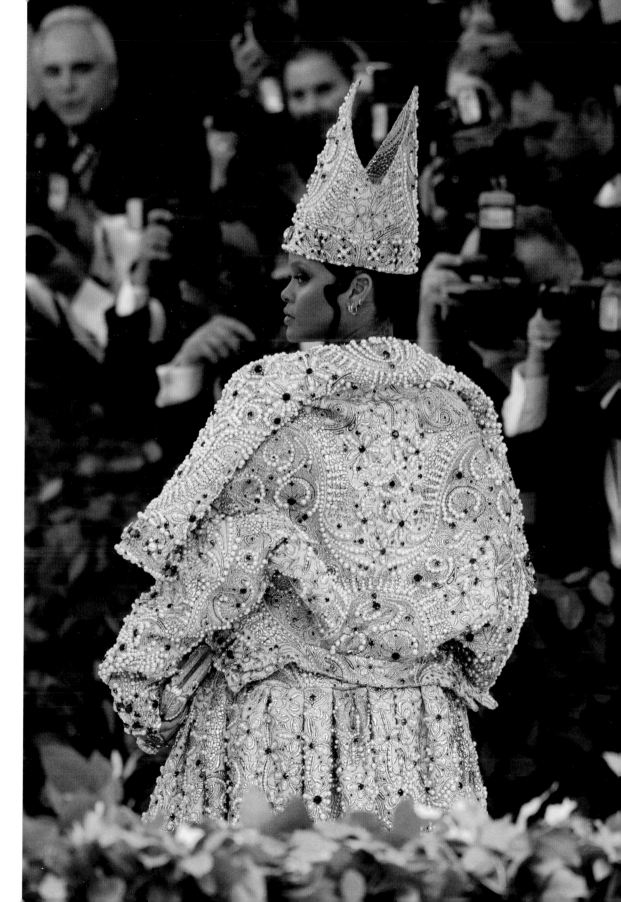

Island Gyal

· ·

'Designing for Rihanna is exciting and fun because there are no boundaries. This allows me to experiment with different looks and I try to incorporate her personality into each costume with my own creative touch. '
— Lauren Austin, Designer, *Paper* magazine, August 2018.

Every couple of years, bar lockdown and pregnancy, Rihanna has flown home to Barbados for Crop Over – 'the Sweetest Summer Festival' – held to celebrate the end of the sugar harvest with singing and dancing. The Kadooment Day Parade signals the closing celebrations, when BadGal rides the carnival float and sparkles most bright. From 2013–15, Trinidadian designer Lauren Austin collaborated with RiRi, hand–making diamanté and jewel–studded bikinis, feathered head–dresses and angel wings for her to wear. In 2019, RiRi broke ranks and turned to Dutch designer David La Porte, who created a baby–pink ostrich–feathered fantasy frock for her to float down the road in. She wore her hair in traditional Bantu knots and accessorised with round, crystal Gucci shades and pointy pink stilettoes designed by Ada Kokosar under her Midnight 00 line – the same shoe–smith RiRi chose to accessorise her Fenty X Savage 2018 show. Her nails were long and dotted with fluoro yellow stars. She arrived at the island looking New York smart, wearing a black satin blouse by Collina Strada, a brand based on climate–consciousness and community. Alongside the statement–shirt, BadGal chose a pair of Fenty 'Spiral' sandals and a Fenty 'XLong draped skirt' to stride the tarmac catwalk.

OPPOSITE: *Rihanna home in St. Michael to celebrate the release of her album* A Girl Like Me, *Barbados. April 2006.*

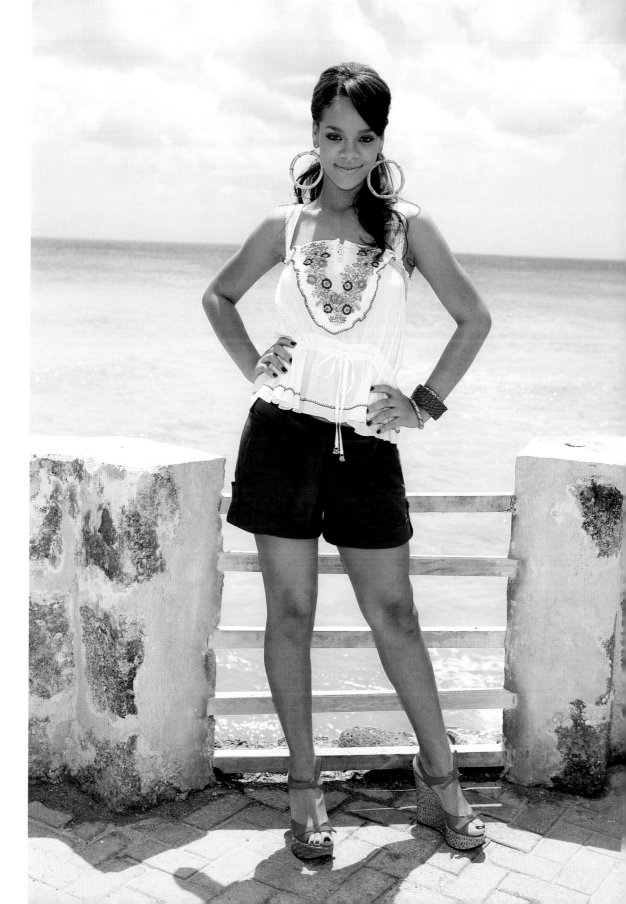

Cap It All

· ·

The semiotics of a baseball cap are easy to read. They've been worn by rap royalty and sports-stars for decades. In the 2000s, as streetwear evolved into the new luxury, designers from Balmain to Balenciaga, Versace to Fendi, introduced them into their mainline collections. Now, a premium label snapback is an essential catwalk piece. One of RiRi's favourites is made by Vietnamese American, Chris Leba, for his R13 line. Leba launched in 2009 having worked at Ralph Lauren, J Crew and Tommy Hilfiger. He told The CFDA he made pains to create a range that resonated with the 'other America: the always provocative underground of culture and art'.

The baseball cap is undeniably an icon of all kinds of American wardrobes, and you can be a fan or player if you wear one. They've also taken up the role that T-shirts have, billboarding politics and passions. Rihanna has been sporting one since she was a child in Barbados and admits wearing them 'was my way of rebelling. I wanted to dress like my brother.'

OPPOSITE: *Out in NYC, 2013.*

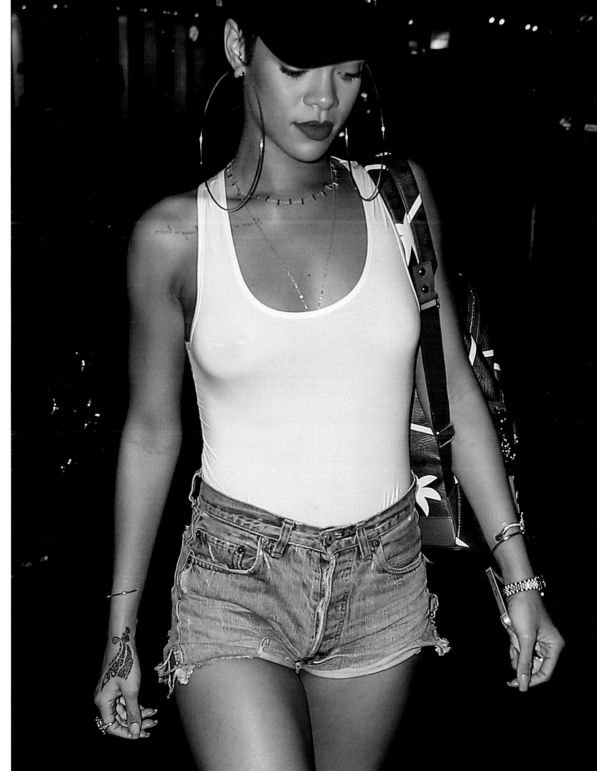

Today, as a megastar, they are an indication of her cool confidence. Always hitting the style out the ballpark, she wears them with couture pieces, business suits and avant-garde designers, casually paired with ripped jeans, and tongue in cheek adorned with slogans including cult menswear label Komakino's 'Teenage Fantasy' and the Paris-based brand Nasaseasons' 'I came to break hearts' classic.

OPPOSITE: *Casual, cool and confident, NYC, 2013.*

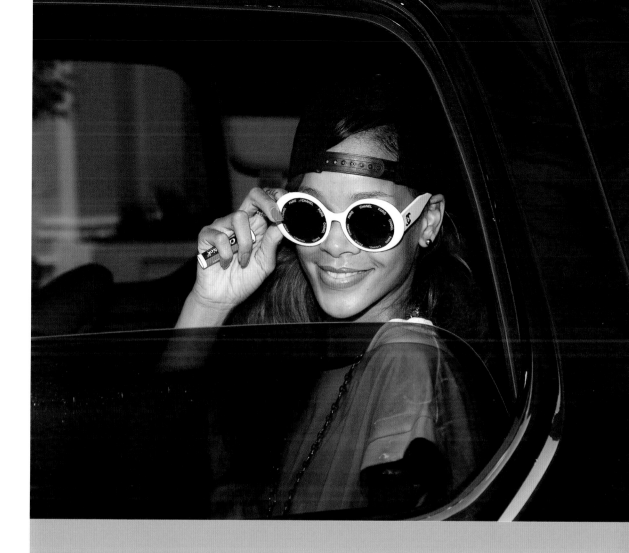

'I used to be scared of wearing baseball caps because I never thought they look good on me but then I saw Rihanna wearing one and now I wear them.... but I still feel like a discount Rihanna. '

— Doja Cat, *YouTube*, March 2022.

Sure Footed

· ·

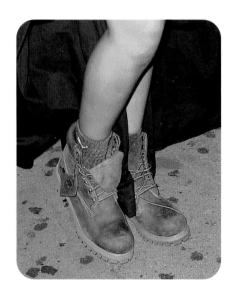

Timberlands are rapper's boots, with a well-earned place in hip-hop fashion's hall of fame. From the streets of Harlem to the videos of Notorious B.I.G. and Tupac, their footwear is fly. Probably the most exhilarating Rihanna music video is a 1-minute promo for the 'Goodnight Gotham' track on her 2016 *Anti* album. It features her 'doing the craziest thing ever' – running head-on into a cheering crowd of fans at the base of the Eiffel Tower in Paris. She does it wearing Dior-overalls and limited-edition Timberland 6-Inch Black Reflective Boots.

Over the years Timberland has had to re-negotiate its favour with the Black Community – at times rejecting its street fanbase, it's had to work hard to regain a positive profile. But as per most rapping royalty, they've always had a place in Rihanna's wardrobe and back at the 2012 Brit and Grammy Awards, she performed the hit 'We fell in Love in a Hopeless Place' wearing a favourite wheat nubuck pair.

THIS PAGE: *Boots on the ground.*
OPPOSITE: *BadGal performs at the 2012 Brit Awards.*

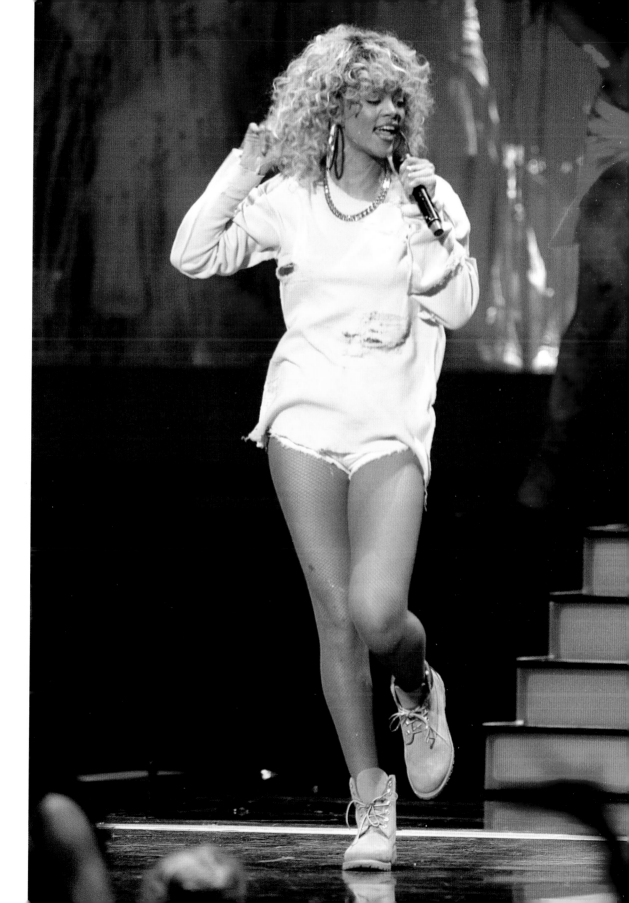

She regularly alternates between those and a choice burnished-brown shade, such as the ones she donned in 2016 while wearing a Hilary Clinton T-shirt by Trapvilla. Similarly in tune with women's rights, BadGal posed wearing Timberlands with Dior's 'We Should All Be Feminists' T-shirt by Maria Grazia Churi. And when Rihanna and Manolo Blahnik chose to collaborate, it was only right that RiRi's favourite footwear manifested its influence – together they initiated their own unbeatable fashion homage to the brown boot and recreated it with the highest of heels and a stiletto toe.

OPPOSITE: *Stepping it up in Manhattan, 2016.*

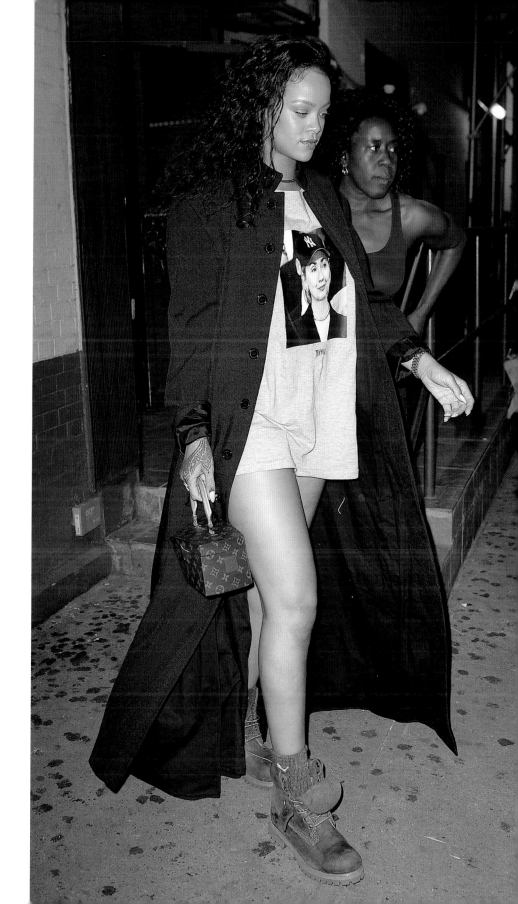

Blow up

· ·

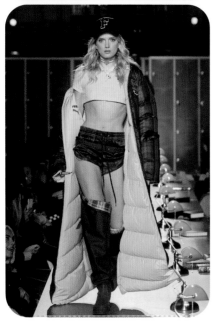

In 1984, Run–DMC released their debut album with a sound that epitomised a new direction for hip hop. What they wore crystalised its style codes. Their signature Double Goose leather jackets went down in fashion history, making the puffer shape an enduring hip–hop wardrobe classic. Also worn by old–skool heroes, like LL Cool J and Rakim, Rihanna included it in the A/W 2017 Fenty–Puma show. The collection embraced a tom–boyish collegiate style and the puffers she created included both a full–length and cropped version in Black Watch tartan. There were also puffers with experimental bell–sleeves that consolidated RiRi's design–form.

One favoured BadGal puffer is a wet–look jet and yellow knee–sweeper designed by Raf Simons for his autumn 2016 menswear collection. She wore it in London, styling it with Fenty X Puma boots and crew socks, making quite a statement. And when it came to her first public appearance since the birth of her first child, in July 2022, the fly–girl stepped out in a feathered Prada puffer bomber jacket to watch ASAP Rocky play at Wireless Festival in London.

THIS PAGE TOP: *Puff daddies – Run–DMC attend a Pro-Peace fundraiser in 1986.*
THIS PAGE BOTTOM: *Runway success – Fenty Puma at Paris Fashion Week, March 2017.*
OPPOSITE: *Hip hop style at Harrods, London, August 2016.*

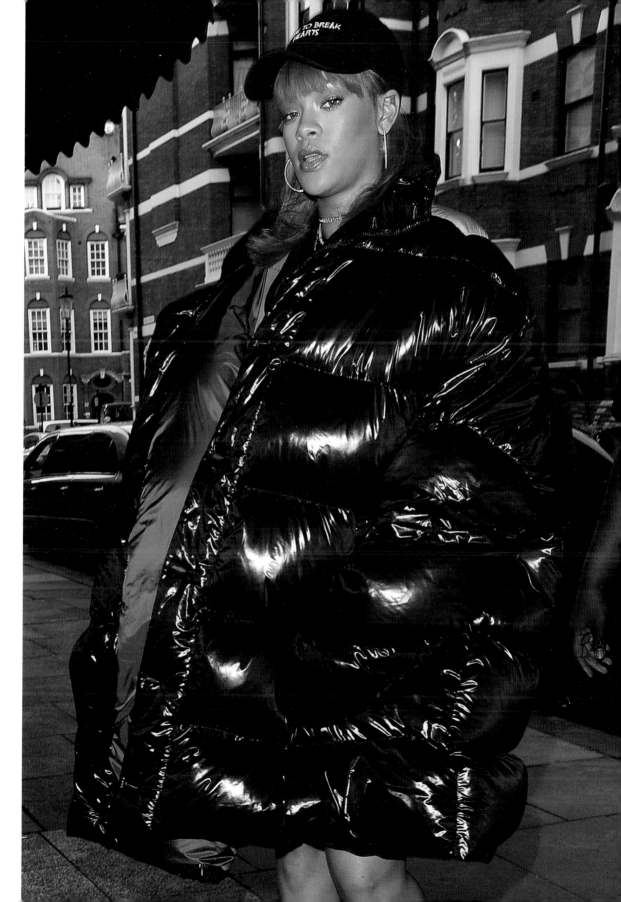

Suits You

' I know exactly who you are...and so do my pockets.
This is Jacquemus by the way. '
— Rihanna Today, *TikTok*, June 2022.

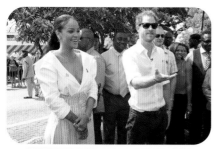

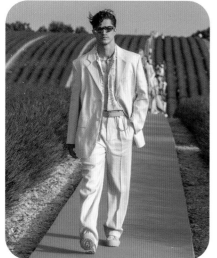

Simon Porte Jacquemus launched his womenswear label in 2009, aged just 19. A decade later, he showed his first menswear pieces in a lavender field in the South of France. His work is glisteningly fresh and he soon caught Rihanna's eye. When she wore a brilliant white suit from that first men's show, he sent RiRi an Instagram note: 'Thanks for the support since day 1. It's amazing how you always wear and support young talent.'

In 2016, when RiRi promoted the 'Man Aware' event held by the Barbados National HIV/AIDS Commission, she went with Prince Harry to take an HIV test wearing an androgynous pair of wide-legged, pin-stripe cream trousers and a cool-white off-the-shoulder shirt from the Jacquemus Summer 2017 catwalk. And Rihanna loves Jacqeumus' womenswear too. To celebrate the naming of a street after her – Rihanna Drive – she carried one of his cult mini-bags in sunflower yellow. Tiny enough to hold nothing, it was a perfect accessory to make a statement with.

THIS PAGE TOP: *Prince Harry and Rihanna raise awareness for HIV testing.*
THIS PAGE BOTTOM: *Jacquemus S/S menswear, 2019.*
OPPOSITE: *Promoting Fenty Beauty at Lotte World Tower in Seoul, South Korea, 2019.*

Luxe Tuxe

· ·

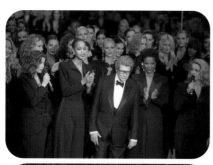

2015 was a momentous year for fashion. It was the year that John Galliano returned to designing as Artistic Director of Maison Margiela. It was a bold appointment, and his first collection was equally brave. His supporters, including Anna Wintour, were cheering him on, despite the scandal that had led to his sacking at Dior in 2011. When Wintour interviewed Rihanna for her 'Go Ask Anna' YouTube show, RiRi said if she were to get married, she'd ask Galliano to design her dress.

At the 57th Grammy Awards in 2015, along with Wintour, BadGal showed her endorsement of the designer by wearing a Tuxedo suit from his debut Margiela couture collection. It was an important gig for RiRi. She sang her new song 'FourFiveSeconds' for the first time, joined by music royalty, Paul McCartney, who was also suited up. Mixing up her menswear take, she chose a pair of pointy–toed Christian Louboutin shoes and a $1 million Harry Kotlar diamond ring to accessorise.

Traditionally a formal dress suit for the chaps, Marlene Dietrich in the '30s and Saint Laurent's Le Smoking in the

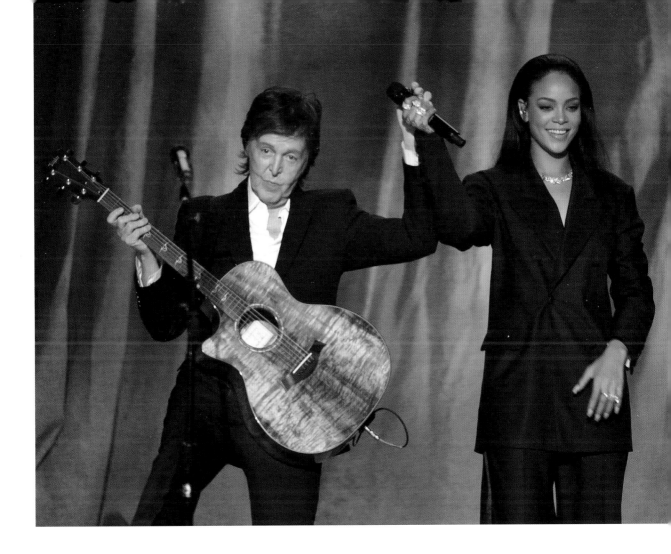

'70s made the Tux an elegant womenswear option. In the '90s, Helmut Lang's androgynous take on the silhouette re– modernised it and made it stylishly minimalist. And in 2019, Rihanna created her own long and lean version in black satin for a Fenty capsule collection. The Tuxedo is a slice of style.

THIS PAGE: *Ri performs with Paul McCartney at the 2015 Grammy Awards.*
OPPOSITE TOP: *Laetitia Casta, Catherine Deneuve and several models wear Yves Saint Laurent's 'le smoking' while posing with the man himself.*
OPPOSITE BOTTOM: *Oozing 'tuxe luxe' on the red carpet at the 2014 British Fashion Awards 2014.*

Big is Very Beautiful

‘ I really love ending the show in an
oversize brown suit because
she can pull that off so flawlessly. ,
— Mel Ottenberg, *vogue.com*, March 2016.

Fashion virtuoso Mel Ottenberg is an uber-connected stylist and fashion director who has worked with some of the world's coolest celebrities, including Chloe Sevigny and James Franco – but his most famous relationship is with Rihanna. The two are friends and as well as making headlines on account of RiRi's fabulous wardrobe choices, together they've produced some remarkable stage outfits.

Back in 2016, when RiRi kicked off her *Anti* tour, Ottenberg had pieces custom made for her that he told vogue.com were out of the ordinary because they 'just feel so anti what you're ever going to expect to see.' When Rihanna's final get-up was revealed to be a colossal, brown, men's suit, designed by avant-garde label, Y/Project, it sent shockwaves. The mutant suit looked like a cross between an Armani power-shouldered 2-piece and the look worn by David Byrne dancing in the Talking Heads 1984 video of their track 'Girlfriend is Better' – for which the singer reportedly had to have a mini-body-frame built before he could put it on.

THIS PAGE: *Pleasant elevation – David Byrne's 'Girlfriend is Better' suit.*
OPPOSITE: *Anti World Tour, NYC, 2016.*

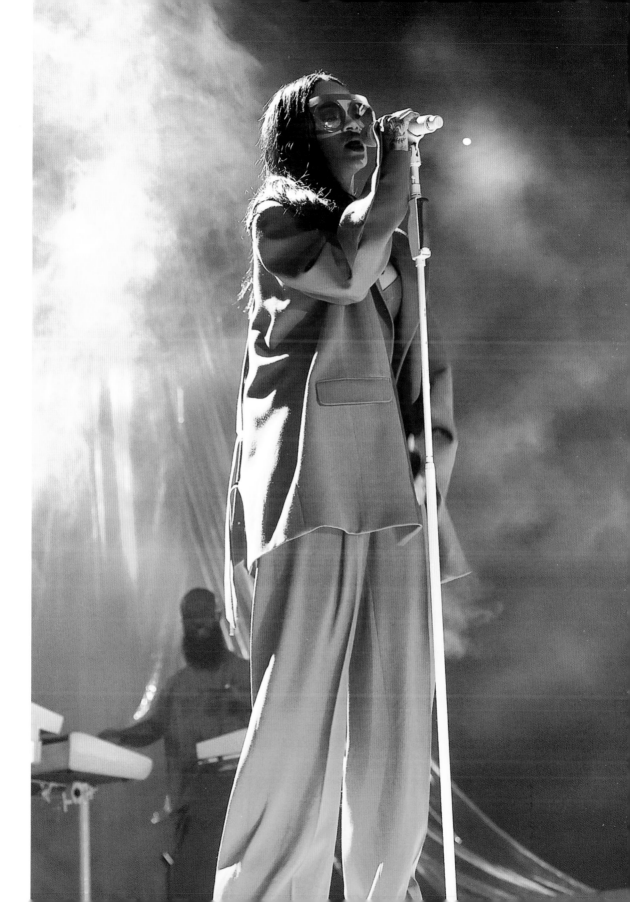

Underneath her version, Rihanna wore a leather corseted lace-up bodysuit by L.A Roxx and a pair of '70s vintage Dior sunnies. A Paris-based brand that self-confesses to exploring the 'eccentric' and 'thought-provoking' aspects of clothing, Y/Project's menswear works well for RiRi. At CBS Radio's third annual We Can Survive concert in 2015, she performed in one of their mannish, S/S 2016, pinstripe suits in navy – matching her hair colour at the time.

OPPOSITE: *Rihanna performs at the Hollywood Bowl in 2015.*

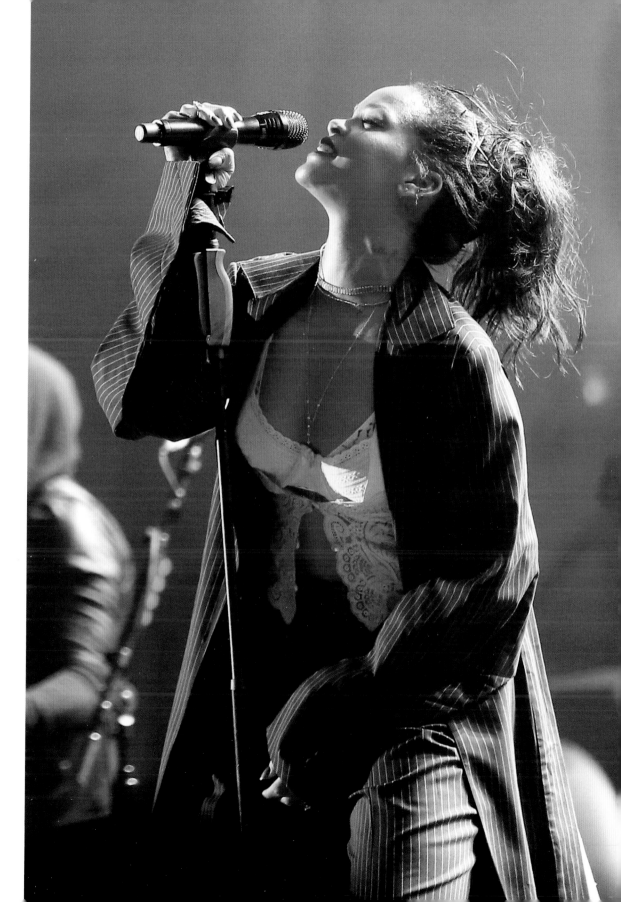

Supreme Leader

· ·

Original fans of skateboard label, Supreme, really helped build the brand. It developed not just as a shop on Lafayette Street, in Lower Manhattan, where you could go and buy cool hoodies, caps and decks, but as a community of connoisseurs who knew the references and understood where founder, James Jebbia, and his team were coming from. Launched in 1994 – a year before the release of Larry Clark's film, *Kids*, which featured skaters who hung out in Washington Square Gardens – it was part of an authentic counterculture that was cool but not well known to those who, well, just didn't *know*. In 2020, the label would be sold for $2.1 billion to VF Corps. Celebrities who wear Supreme either fit right or fit wrong. Rihanna was just six when the store opened, but in 2013 – at the ripe old age of 25 – when she starred in ASAP Rocky's 'Fashion Killa' video and wore a Supreme top, she fit right.

In 2017, at her favourite festival, Crop Over, she arrived wearing a denim jacket from the Supreme X Louis Vuitton collab, with matching blue hair. She wears their pants peeking out from low-slung baggy jeans and their leather jackets with Balmain and Burberry, along with vintage Air Jordan sneakers. As Supreme became more well-known it kept its credibility largely because style cognoscenti such as RiRi kept mixing and matching and making it work. She

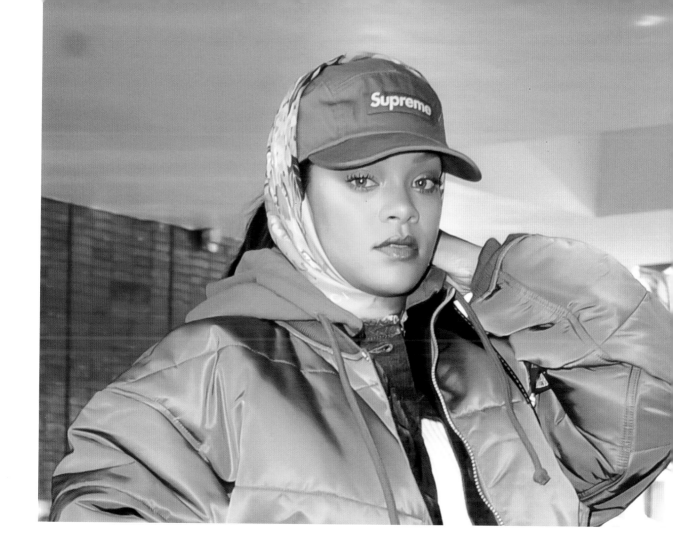

knew when to be weird, casual, or glamorous with it. In 2017, taking a walk in Soho, NYC, she wore one of their sold-out camp-caps with a Gucci, Grey-Gardens-esque, Little Edie headscarf, a cropped Margiela M6 top, Fenty X Puma boots, a Dior bag and Vetements X Alpha Industries bomber jacket and looked supremely fabulous.

THIS PAGE: *BadGal in Soho, NYC, 2017.*
OPPOSITE: *Supreme queueing at the Supreme shop in London.*

Palace Party

UK skate brand, Palace, was founded by Lev Tanju and Gareth Skewis in 2009 and exists as a marker along the trajectory of streetwear as an evolutionary phenomenon. It makes clothes to skate in but also not to skate in. It's a label that's hyper–aware, full of humour, expectation, and aspiration. Palace's success is born from a confident appropriation of London codes and cool, and a keen understanding of what else is cool in the world, which is at the heart of its much–loved collaborations – including their own versions of Reebok's 'Classic' trainers and Ralph Lauren's velvet slippers. Wherever their design eye lands, it always hit the right spot. There are a lot of parallels between this sticky boys' skate–brand that grew out of a squat in South London and Rihanna's approach to fashion and she happily dips in and out of their characterful world, picking key pieces and wearing them with the same insightful style. On Ri, white Palace track–pants, usually an athleisure basic, are worn with a Chanel boucle jacket. Rihanna has the same value system as Palace when it comes to fashion – she confuses and constructs new ways of doing and wearing. Insane!

THIS PAGE: *Lev Tanju at Dover Street Market, London, 2019.*
OPPOSITE: *Arriving at JFK Airport, 2019.*

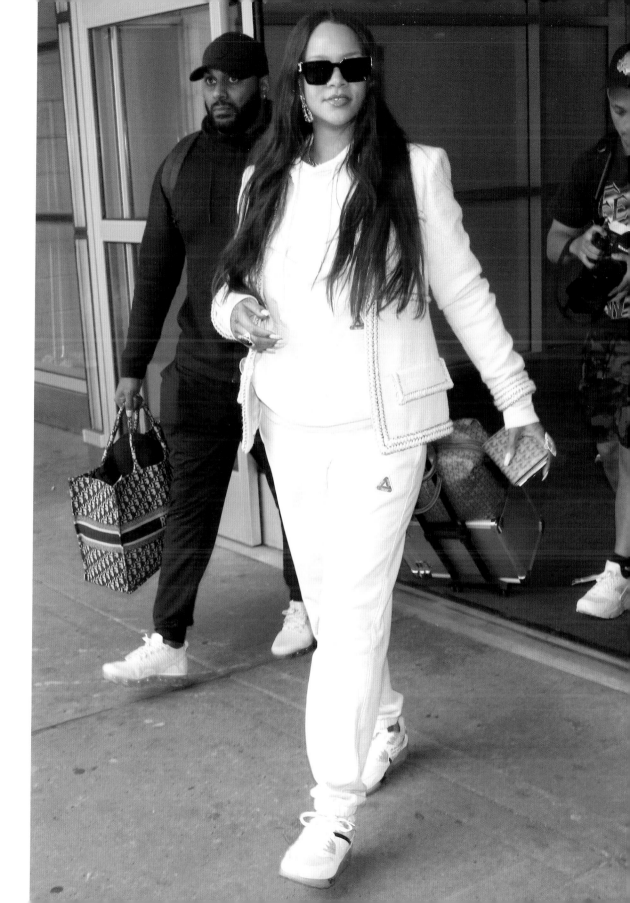

Track Star

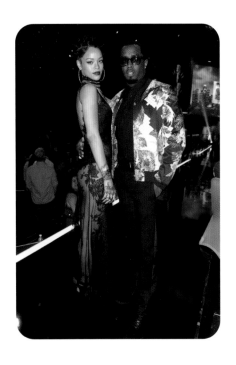

Rihanna knows the language of streetwear better than anyone, so it's no surprise that one of her favourite tracksuits comes from the legendary Sean Love Combs label, Sean John. Better known by his stage name, P. Diddy (or Puff Daddy to older fans), Combs said his intention when launching the range in 1998 was to build 'a premium brand that shattered tradition and introduced Hip Hop to high-fashion on a global scale.' Born in Harlem, the Grammy Award winning rapper, who also founded Bad Boy Records in 1993, has described his own style as 'swagger, timeless, diverse'. This was the vibe he brought to the Sean John table – an attitude that made the label iconic in the late '90s and early 2000s. He sold a majority stake in the company in 2016 but in 2021, Diddy bought the label back, ready for re-launch. His 'vintage' pieces are highly collectible and in 2015, Rihanna was spotted wearing an SJ pink velour trackie, perfecting the look with a Diorama bag and wedge Degen Antibody boots.

THIS PAGE: *Rihanna and Sean 'Diddy' Combs backstage at the 2014 iHeartRadio Music Awards.*
OPPOSITE: *Attracting attention – RiRi in vintage Sean Love Combs.*

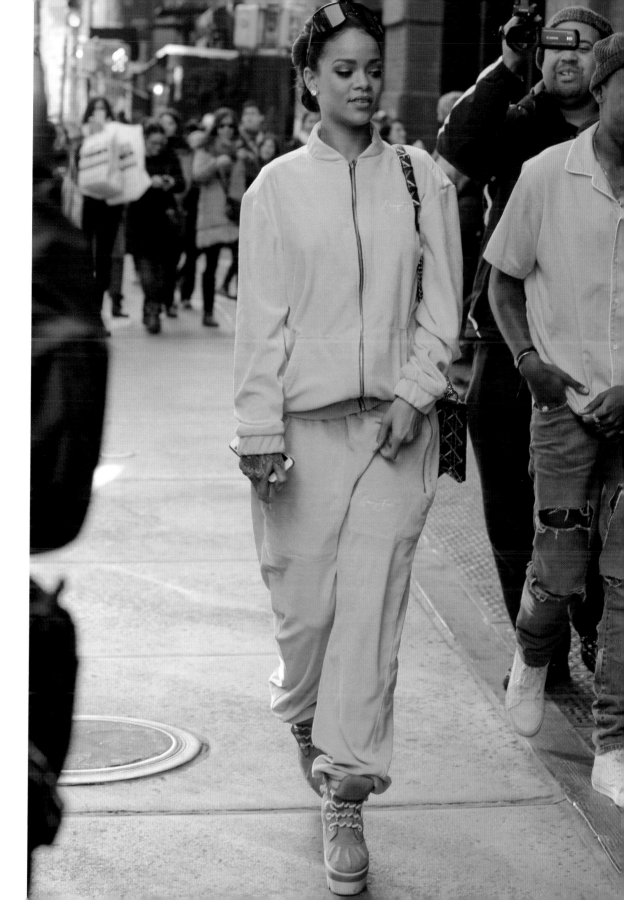

It was the year RiRi would become one of Dior's 'faces' appearing in 'The Secret Garden' advertising campaign shot by Steven Klein in the Palace of Versailles. RiRi's approach to remixing and matching atypical fashion and streetwear pieces is catnip to luxury conglomerates such as LVMH and DKNY, and has helped redefine how big fashion houses express fresh narratives, compelling a new renaissance full of swagger and timeless diversity.

OPPOSITE: *RiRi rocking high-fashion casual at LAX Los Angeles, California, November 2014.*

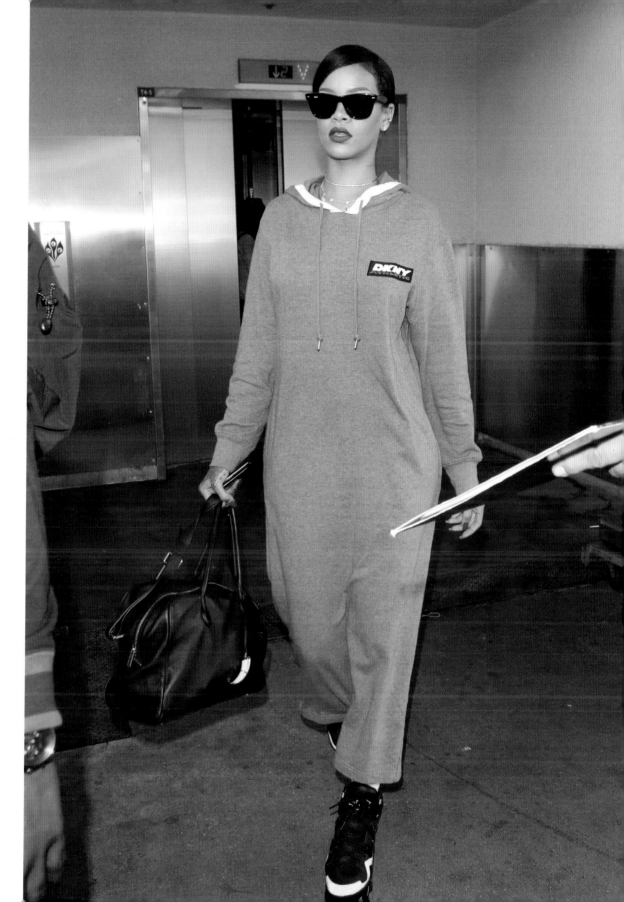

Girls in the Hood

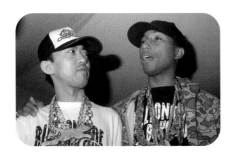

When Forbes released its America's Richest Women 2022 list, Rihanna's net worth was reported as $1.4 billion. In terms of ranking, she came in as the year's youngest and Barbados's first billionaire, landing number 21 on the overall list. She started wearing Billionaire Girls Club hoodies back in the mid–2000s – little did she know the streetwear brand's slogan would come true for her. Record producers, DJs and fashion designers Pharrell Williams and Nigo founded the Billionaire Boys Club brand in 2003 and its sister 'Girls Club' in 2011. Their brand mission statement declares: 'Wealth is of the heart and mind. Not the pocket.' The label is known for its luxe, covetable, pop streetwear. But philanthropy is at the core of its purpose and the brand has aligned with issues like Black Lives Matter and Stop Asian Hate. Activism still motivates its designs and in 2022, BGC returned to stores after a 3–year break. The first capsule collection was created to celebrate International Women's Day and Women's History Month, during which the brand hosted a podcast at its SoHo store in New York to discuss women and streetwear. Money isn't everything after all.

THIS PAGE: *Nigo and Pharrell Williams, Tokyo.*
OPPOSITE: *Looking swish in a Billionaire Girls Club hoody.*

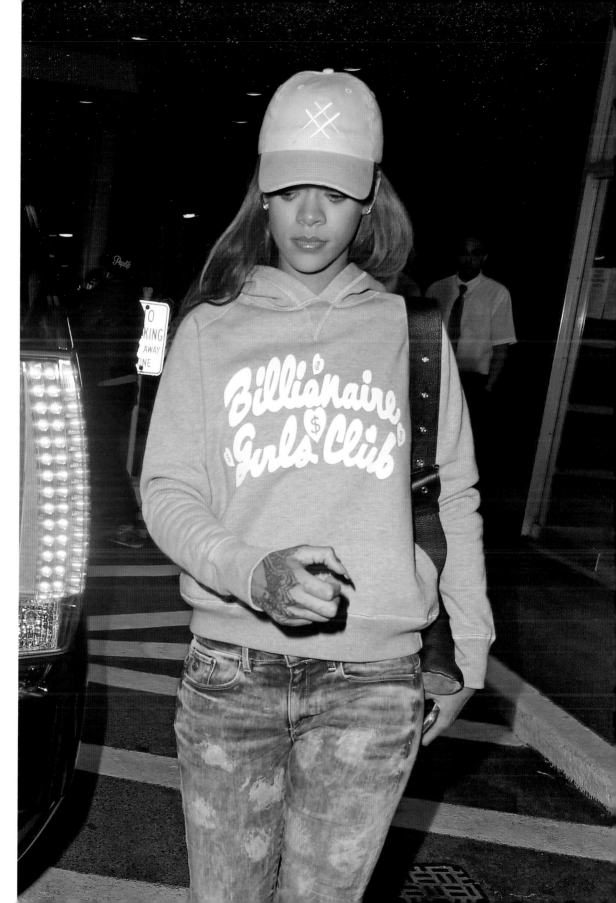

Star Quality

'I've always wanted to collaborate with Rihanna, but I never thought about it too much. We didn't necessarily think that it was possible. That was really her just wanting to break a boundary. '

— Mikey Trapstar, *Complex*, August 2014.

When Rihanna and Eminem played their 6-date 'The Monster' tour in 2014, it was worth marking with slick merchandise. They turned to Trapstar – an underground micro streetwear brand launched in 2005 – to help create something just right. In an interview with *Complex*, Trapstar co-founder Mikey explained how Rihanna's input was crucial: 'We did a crazy amount of designs, and she's hands-on, so we bounced back and forth. She'd give ideas and whatnot. So, it was a joint effort.' Rihanna knew the brand from its early days, when its collections were delivered in customised pizza boxes. She was an early adopter, wearing their gothic-font logo caps, jackets, and sweatshirts, helping to spread the word beyond the small enclave Trapstar routinely frequented in London. The merchandise included the now collectible long-sleeved T-shirt with a graphic featuring Ri's eyes collaged with a moon, gold grillz and demon horns. It wasn't the first time Trapstar had collaborated. Back in 2012, BadGal was spotted wearing a personalised Agent 47 bomber jacket from their joint venture with the Japanese video game, *Hitman: Absolution*. Despite the huge gaming fanbase, the scheme felt strange and nicely niche, something every mega-watted super-star like RiRi can still connect with.

OPPOSITE: *Trapstar hat and jacket.*

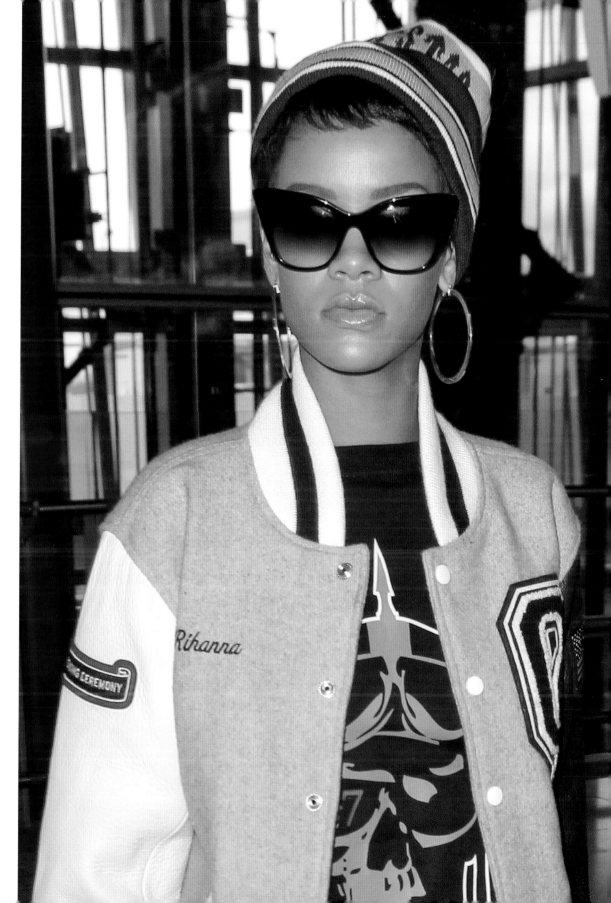

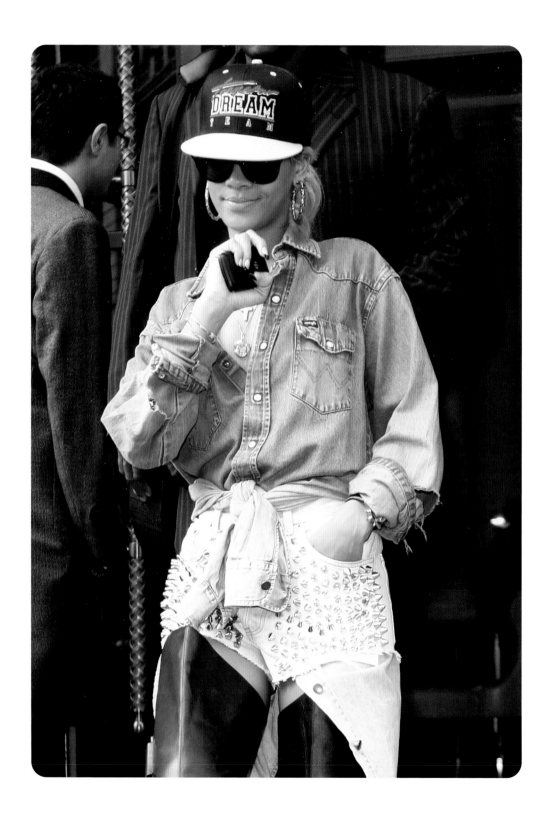

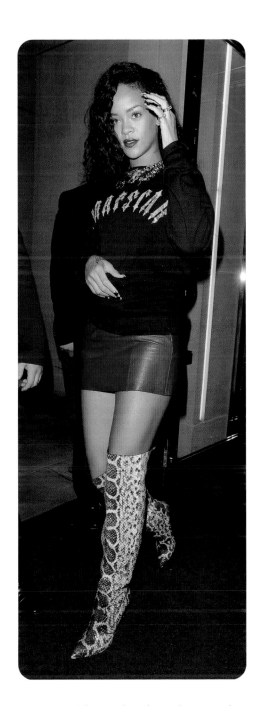

THIS PAGE: *Rihanna heads out for a very late supper in Trapstar and snakeskin boots, London, 2012.*

OPPOSITE: *International cap – Ri reps a Trapstar hat on the way to the Jonathan Ross show, London, 2012.*

Ri X Matthew Adams Dolan

Parsons School of Design is probably the most famous art school in the world. Its fashion designer alumni are certainly among the most celebrated talents: Tom Ford, Marc Jacobs, and Willi Smith to name a few. The academic institution knows a good thing when they see it and in 2017, they recognised Rihanna for her fashion influence and support of young design talent. The tribute was elegantly reciprocated. RiRi said on the night: 'It's such a thrill to know that a design school as prestigious as Parsons School of Design would present me with this honor. I consistently find creative and exciting designs coming from Parsons alumni, so I feel a deep connection to the school.'

For the evening, she looked equally elegant and wore a beige, jumbo tailored suit by Australian born Matthew Adams Dolan, a 2014 graduate. She told viewers of *Access Hollywood*: 'He's one of my favourite designers, and it was only fitting, coming to Parsons that I wear him.' She wore the outfit with Manolo heels and diamonds.

OPPOSITE: *Ri visits Tramp Club after playing Wembley Stadium, 2016.*

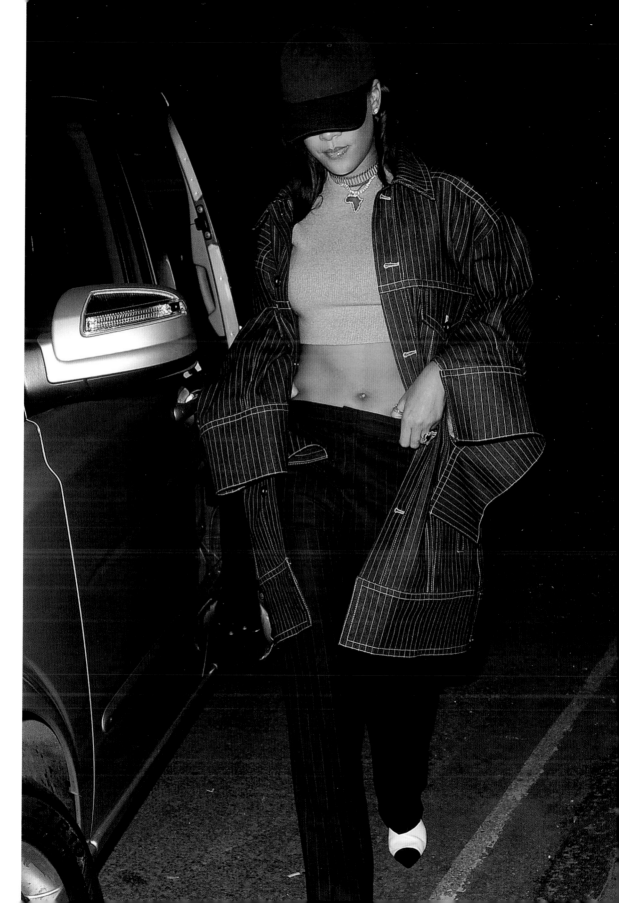

Back in 2016, during RiRi's 'Anti' Tour, she wore Dolan while clubbing – a custom, pin-striped denim jacket in his signature oversized silhouette, teamed with Jaquemus trousers and Chanel mules – and has consistently followed him over the course of her career. For a high-profile Stance for a Clara Lionel Foundation event in 2018, she dressed in a Dolan avant-garde, pale-blue, satin, off-the-shoulder gown. While at Coachella the year before, she sported his sexy slit denim pants, shrugged-on denim jacket and a pair of wedge Margiela Tabi boots.

THIS PAGE: *Ri making her honoree acceptance speech at the 69th Annual Parsons Benefit, 2017.*

' I don't think you get celebrated enough. You should be celebrated for every aspect of your growth and your growing pains. You should be celebrated for your creativity, for your fearlessness, for your persistence and determination... for being different, for not being given enough credit. For not having to use eye cream! '

Rihanna, on Millennial fashion designers, Annual Parsons Benefit, 2017.

THIS PAGE: *Appearing at Stance for the Clara Lionel Foundation, 2018.*

Rihanna X Adam Selman

'This is it. We can't go any more naked than this. We've slowly gotten here. And now I'm naked with Swarovski crystals on a red carpet. This is the nakedest we gonna go. '
— Rihanna, *Access Hollywood*, July 2014.

When Rihanna was named CFDA Style Icon of the Year in 2014, no one in the room could disagree she was the rightful winner. Especially witnessing the outfit she chose to wear to accept the award from Anna Wintour, Editor in Chief of US *Vogue*, that night at The Lincoln Centre's Alice Tully Hall on the Upper West Side in New York. It was her version of Marilyn Monroe's 'naked' dress, this time created by her close friend and designer, Adam Selman, with a lot of input from RiRi herself. Selman explained to *Elle* magazine the method behind its conception: 'She was very exact with what she wanted. She always is. We dyed the mesh to be her exact skin tone. She also asked me to mix plain crystals in with the colorful ones, and in person it made such an amazing difference. It added a depth I wasn't expecting. Her instincts on these decisions are always spot on.' Later that year Rihanna would reiterate her relationship with Selman by attending his S/S 2015 show during fashion week. The two hugged and twirled for the camera, RiRi wearing a custom version of one of the catwalk pieces, accessorised with pearls and Louboutin pumps.

OPPOSITE: *Anna Wintour and Rihanna style it out at the winners' walk, CFDA fashion awards, NYC, 2 June 2014.*

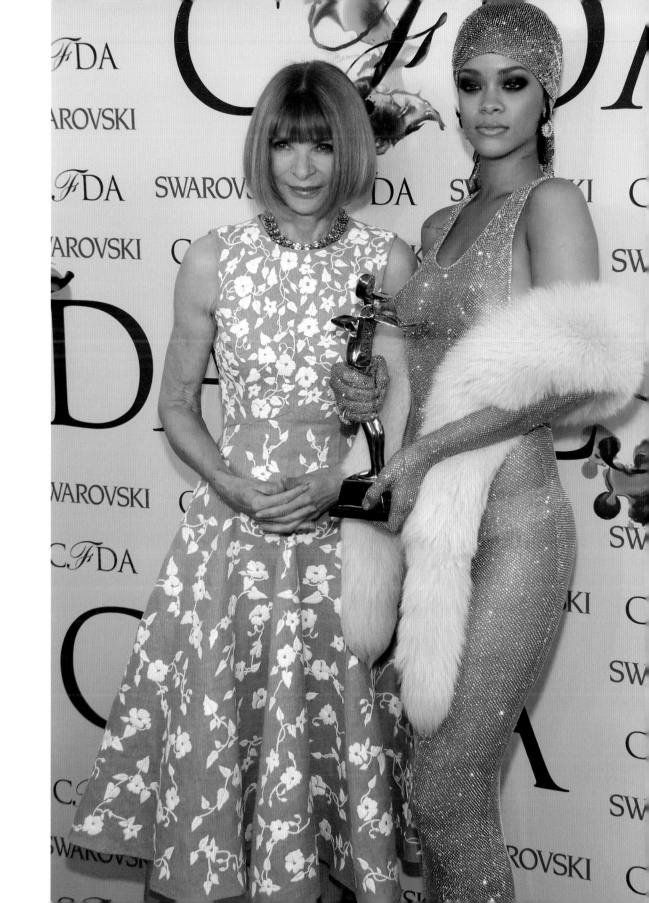

Selman was born in Texas, graduated from Pratt Institute in 2004 and was the designer Rihanna turned to for help to produce her River Island capsule collection in 2013. And again, in 2020, he was the first designer she looked to for a collaboration on her own Savage X Fenty lingerie line. Rihanna clearly trusts his judgement. In 2018, for the Grammy Awards, when Ri sang 'Wild Thoughts' with Bryson Tiller and DJ Khaled, she wore a pink, fringed gown created by Selman. It was a showstopper adorned with 50,000 more crystals than *that* CFDA frock. He said in a 2014 interview: 'You can give people good clothes, but you can't give them style.' With Selman at her side, BadGal has both.

OPPOSITE: *Ri teams pearls with a white Selman mini to look* almost *angelic at Adam Selman's presentation during Spring 2015 Fashion Week, NYC, 5 September 2014.*

Rihanna X Martine Rose

An exploration of big silhouettes, London subcultural streetwear, Jamaican roots and an approach to style that fuses menswear into clothes for everyone are all integral elements of Martine Rose's collections. Born in 1980, she references lovers' rock, dancehall, rave, hip-hop and punk – bona-fide fashion moments born underground before her time. How she orientates these inspirations feels uniquely English but translates easily into the lingua-franca of the world's style cognoscenti and has caught the eye of international names including Demna Gvasalia, who gave Rose a job as a consultant when he first moved to Balenciaga as Creative Director in 2015. Rihanna is a big fan; her signature codes hit all the right RiRi sartorial spots. Rose debuted her label in 2007 and was short-listed for the LVMH Young Designer prize in 2017. Since then, Rihanna has faithfully supported the cult favourite. BadGal typically styles the label in her own inimitable fashion, wearing an over-sized Rose football shirt as a dress with heels, a terrace-chic shell-suit trackie top with a fur stole, or a re-worked faux-fur coat adorned with

THIS PAGE: *Martine Rose menswear, London Fashion Week, June 2018.*
OPPOSITE: *All smiles in New York City, October 2014.*

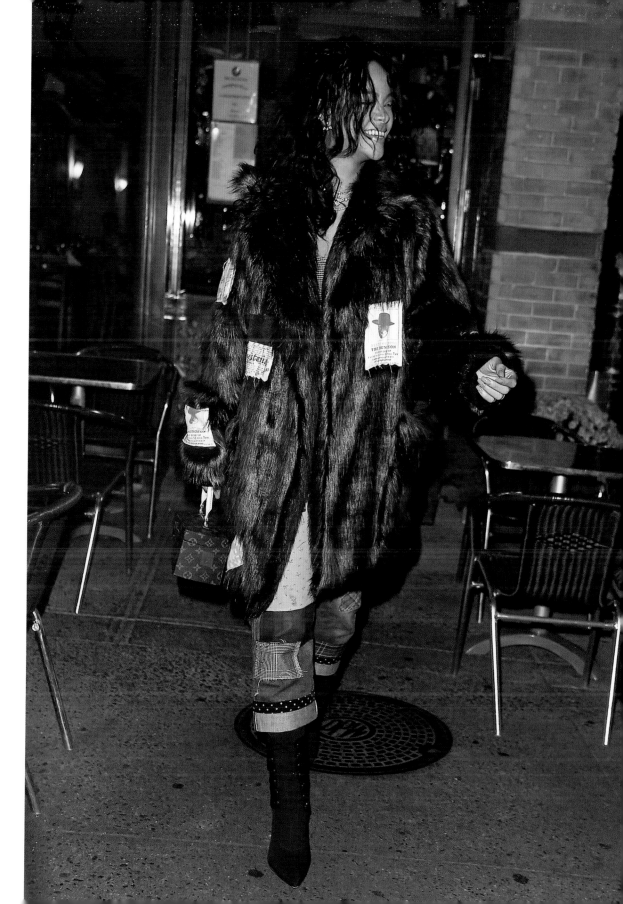

fabric flyers and a sell–out pair of Junya Watanabe patchwork jeans – all the time twisting Martine Rose's take on alternative cultures and taking them one step further. Ri looks good in menswear, but it doesn't always look like menswear clothing when she wears it, and this is something Martine Rose has tapped into – her work feels modern and won't be pigeon-holed. At the CFDA awards, Ri said: 'Fashion is a world of thrills. There are no rules. Well, there are rules, but rules are there to be broken.' Something she and Martine can agree on.

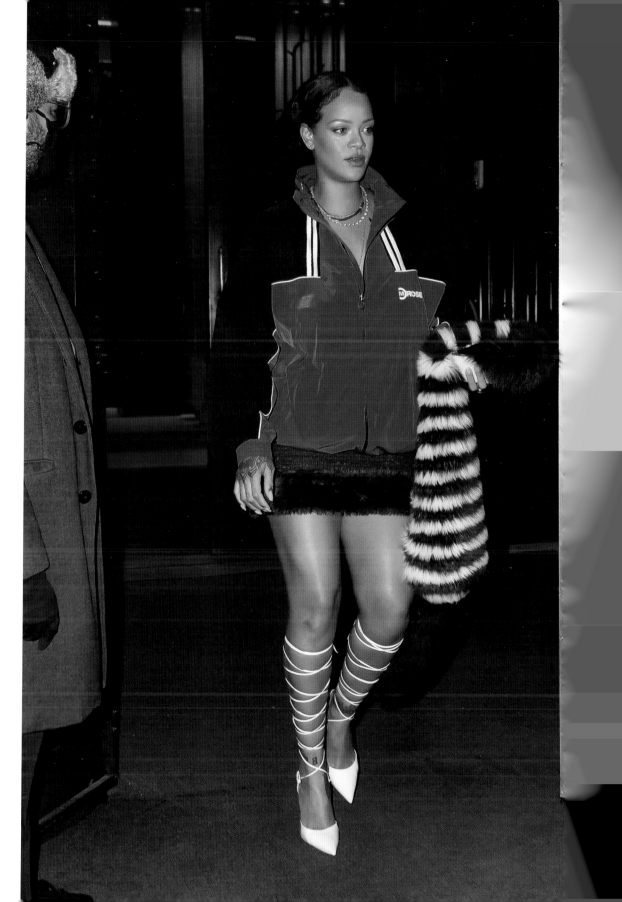

Rihanna X Hood by Air

Shayne Oliver's Hood by Air (HBA) brand started small – he made some T–shirts back in 2006 with his original partner, Raul Lopez, and sold them to friends and family. When the label hit the bigtime in 2010, Oliver's work felt in tune with some of the principal fashion stars showing on international catwalks. Rihanna picked up on the boy from Minnesota, who grew up in Trinidad and Brooklyn, and wore his name on her sleeve. When she wore a pink poodle HBA shirt in 2012 and the image was seen around the world, it felt like an authentic connection. He was certainly part of the vanguard of designers traditionally steeped in streetwear roots who would go on to create new BIPOC–inclusive luxury and tread fresh ground with counter–culturally inspired avant–garde silhouettes. In 2016, when Rihanna played at the MTV Music Awards in Madison Square Gardens, she opened with a greatest hits singalong, wearing an HBA baby–pink custom cookie–ringer bodysuit, mini–skirt corset, and zip–detailed chaps – a get–up inspired by Oliver's spring 2017 collection. It made a big HBA statement. Even in pastel shades, Shayne Oliver's BDSM fascination properly pumped up the volume.

THIS PAGE: *Hood by Air S/S 2017 collection.*
OPPOSITE: *Rihanna performs onstage during the 2016 MTV Video Music Awards at Madison Square Garden.*

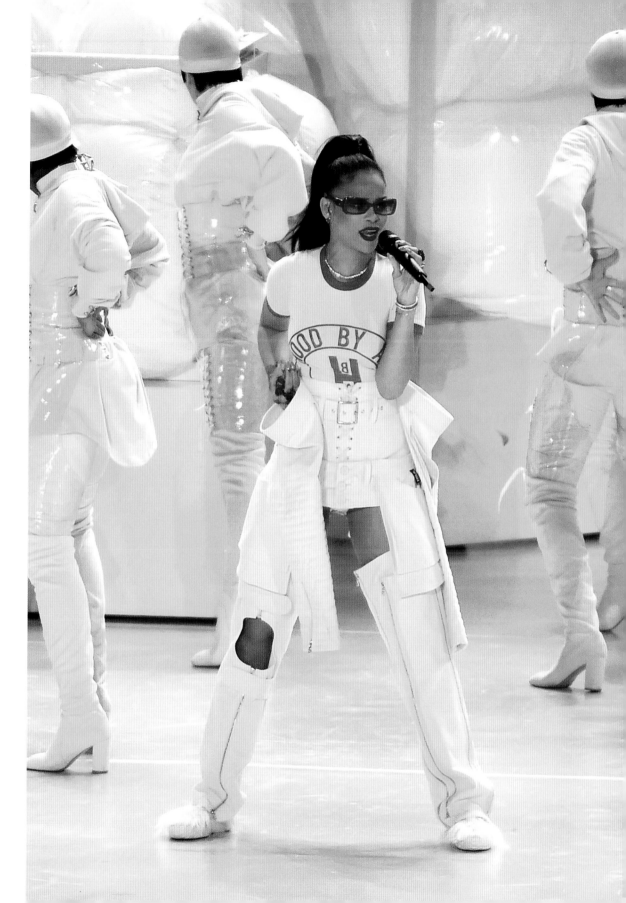

What Goes Around...

From 1980s Thierry Mugler to '90s Alexander McQueen, vintage designer–wear is about sustainability, individuality, and collectability. However, competition is fierce for historically interesting fashion moments, and the big Parisian Houses, from Chanel to Saint Laurent, as well as museums, are steely about their archives. More than ever, these big hitters are also sourcing pieces from past collections to add to their annals for posterity and research. Auctions have become the new shopping malls, where experts congregate or dial in by phone to place bids on some of the rarest finds.

Details of knowledgeable vintage dealers are gold–dust for private collectors, connoisseurs and designers who need inspiration. Contacts are keenly cultivated for insider transactions. As for celebrities, wearing vintage offers some independence from a fashion system that relies heavily on buying personalities to wear looks on the red carpet.

OPPOSITE: *60th Annual GRAMMY Awards, 2018.*

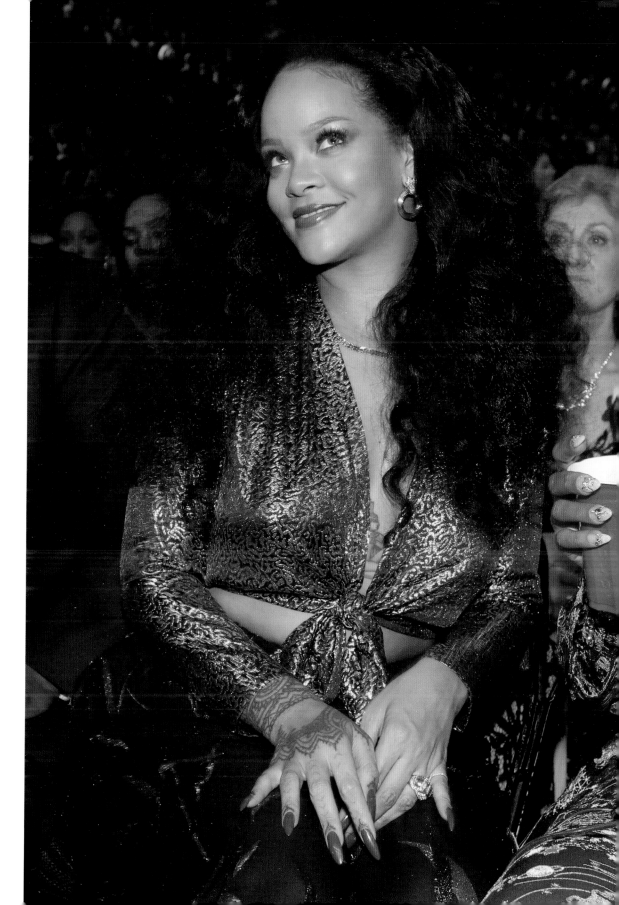

Rihanna is an experienced style ambassador, but her authority comes from mixing, matching, and wearing what she wants when she feels like it. Over the years, she has shown off an impressive array of vintage fashion treasures. For the Grammy Awards in 2018, BadGal wore a pair of '80s lurex harem pants and a tie-front blouse by Yves Saint Laurent. Out for supper in Santa Monica in 2021, Rihanna wore a Mongolian lamb-collared, blue velvet tie-dyed coat from one of John Galliano's early catwalk shows for Dior. Galliano is one of the fashion world's most collectible designers, and the pieces he created while at Dior are heavily sought after. Ri is especially keen on Galliano too – for the première of *Queen & Slim*, she dressed in a S/S 1995 black satin kimono from his eponymous label. In fact, when she hosted the Met Gala's Heavenly Bodies themed event, the beaded Papal robe and mitre hat was based on John's Dior autumn 2000 collection – an outfit modelled by the only man on the catwalk.

OPPOSITE: *Out in LA, 2021.*

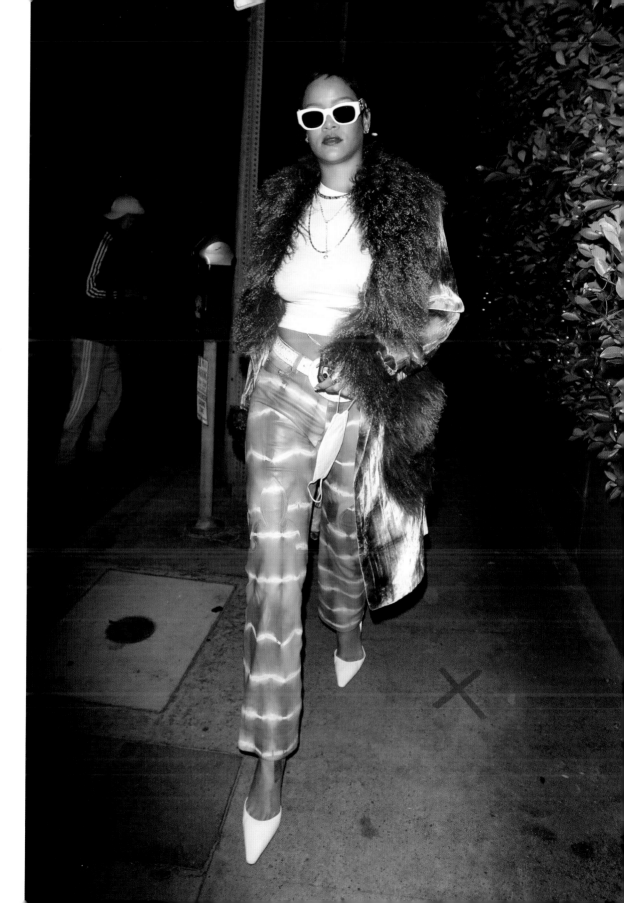

This is typical of the way her eye travels: she'll wear a medley of vintage easily – from pastel bouclé Chanel to Adidas RunDMC red, white and black sweatshirts. Tom Ford's 1999 Gucci feathered jeans are an instantly recognisable classic and of course, Ri has a pair, while vintage accessories are in the mix too. She wore those feathered jeans with a 'custom foxy faux fuzz dome hat' by British designer Benny Andallo to pop to a bookshop in LA. And at a Champions League match in Turin in 2019, she flaunted an inflatable Louis Vuitton ballbag made to celebrate the 1998 World Cup.

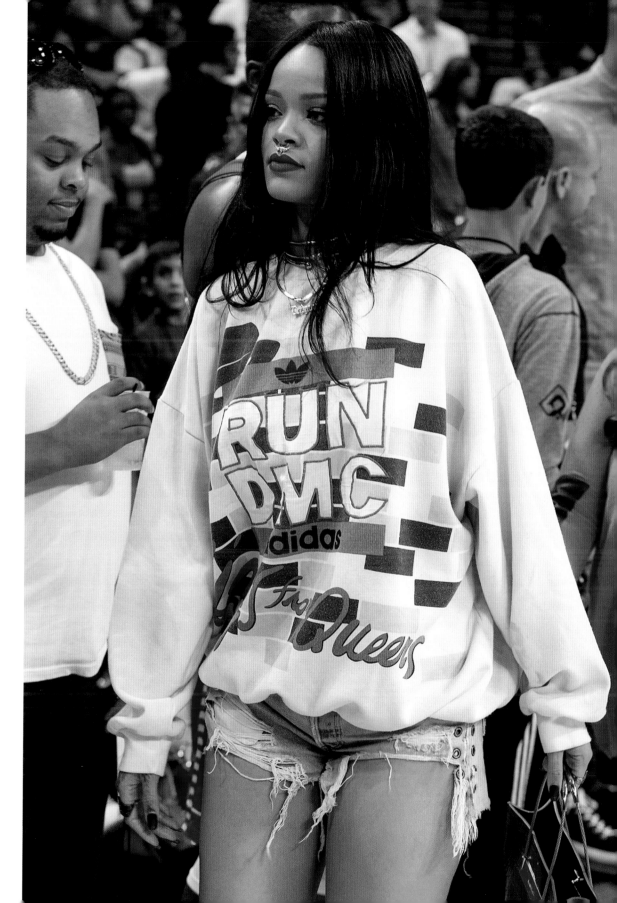

River Deep

· ·

‘ I find London really inspiring
and River Island loves to have fun with clothes.
I'm looking forward to working with them and
creating something really special. ,
— Rihanna, River Island press launch, July 2012.

'I've been wanting to design my own collection for some time,' explained Rihanna at the 2012 press launch of her collection collaboration with River Island. She was 24 years old and had been in the spotlight since signing to Def Jam in 2005. Ri was style conscious way before then and revealed at the CFDA Awards ceremony in 2014, that fashion had been her 'defence mechanism' growing up. So, conceiving her own line was a natural step. West London based brand River Island gave her the infrastructure and the world sat up and took notice. Debuting during London Fashion Week in February 2013, her FROW included super–model Cara Delevigne who partied with her to celebrate and wore the sporty–streetwise range to support BadGal. The range, co–designed with her favourite young designer, Adam Selman, was applauded by industry insiders and as the collections moved forward, so did Ri's confidence. When it came to the subsequent A/W drops in September 2013, she revealed to *Elle*: 'I got a lot of freedom and I got to put a lot more of myself into it. I had so much fun designing it for summer/

THIS PAGE: *Rihanna for River Island at London Fashion Week, February 2013.*
OPPOSITE: *Launch party at DSTRK, 4 March 2013.*

spring that autumn was just – it was just balls out. We had fun and just went for it and did things we didn't get to do before, and that's why I'm excited. That's what's special about it – it's different, it's fresh.'

The collections were designed for 'sexy tomboys' and featured pieces Rihanna would wear, including 'crop tops, sporty lingerie, bomber jackets, floor-length mesh dresses, body-con minis, slouchy knee-length shorts, oversized jumpers, and tiny hotpants,' said Selman. In retrospect, RiRi's career as a designer has built on and refined many of these initial shapes. She started as she meant to go on.

OPPOSITE: *Wearing the River Island A/W camo jumpsuit and beanie, NYC, 2013.*

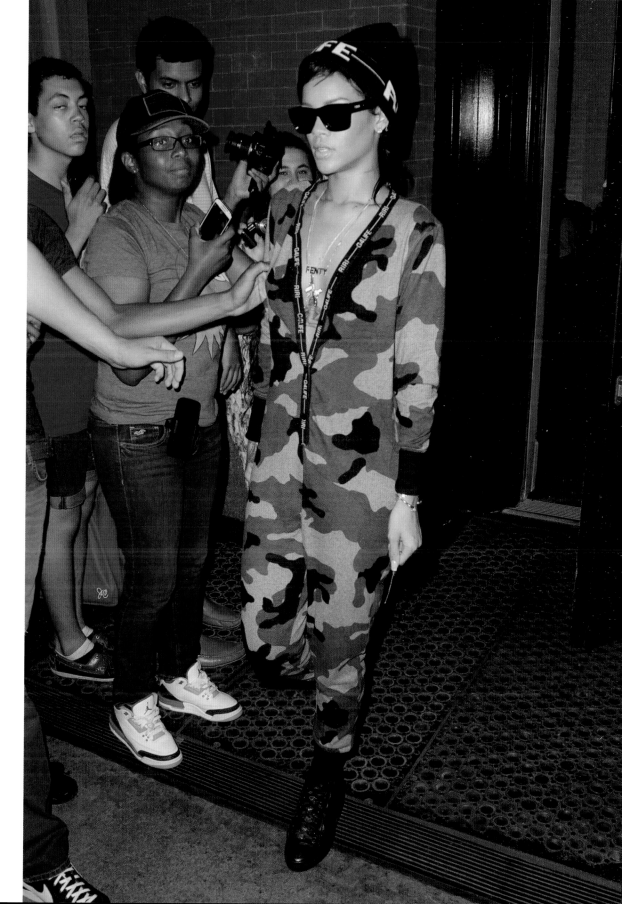

Best Foot Forward

' The day I see a woman in
the street wearing my shoes...
I am sorry for that woman because I'm going to literally run after
her, shouting, "Stop! Selfie! Who are you? Where did you get them?"
I'm going to have a moment! '

— Rihanna, *Vogue*, April 2016.

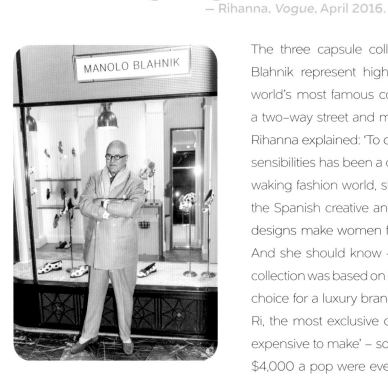

The three capsule collections RiRi designed with Manolo Blahnik represent highest–level fashion. Working with the world's most famous cobbler is indeed a privilege, but also a two–way street and most definitely a meeting of minds, as Rihanna explained: 'To collaborate with him and combine our sensibilities has been a dream come true.' As with most of the waking fashion world, she was a fan before she worked with the Spanish creative and knows the power of his heels: 'His designs make women feel incredible when they wear them.' And she should know – she's worn a lot of them. Their first collection was based on Ri's favourite fabric: denim. An unusual choice for a luxury brand and even more so as, according to Ri, the most exclusive design, a thigh–high boot, was 'really expensive to make' – so much so that only a mere 45 pairs at $4,000 a pop were ever produced. But Manolos are known for their elegant craftsmanship and the time taken to make each pair is time well spent. Rihanna's initial Manolo moment was followed up with two subsequent collections. 'Savage' presented a range of winter boots, and 'So Stoned' in 2017, featured transparent heels and Swarovski studded detailing.

THIS PAGE: *Manolo Blahnik attends his shop launch at Burlington Arcade in London, 2016.*
OPPOSITE: *Those are Manolo's.*

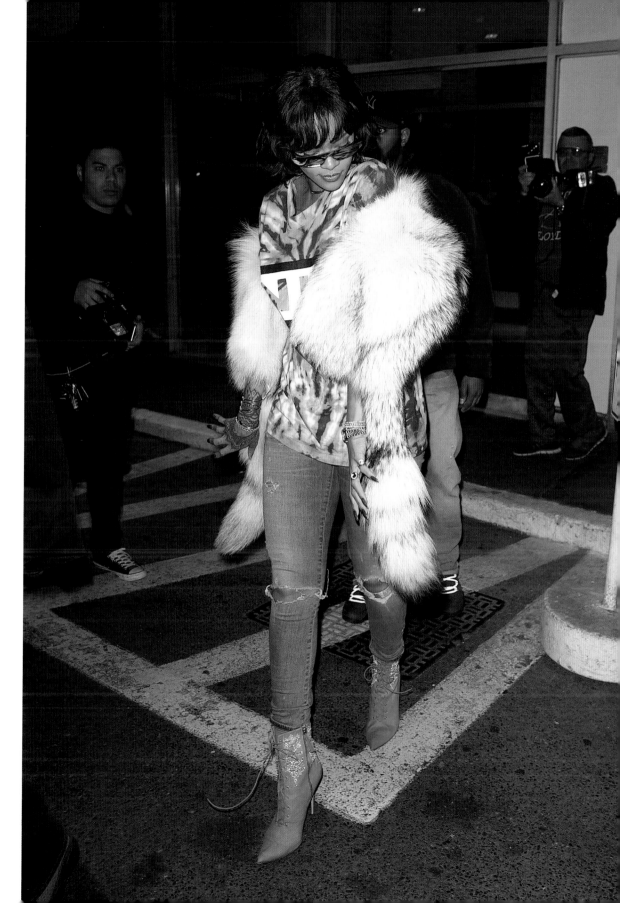

Big Deal

Coinciding with RiRi's appointment as the face of Emporio Armani Underwear and Armani Jeans for their A/W 2011–12 campaign, the Italian luxe house asked her to work on a capsule collection. BadGal created a range including jeans (embellished with a 'Rihanna for Armani Jeans' patch on the backside), biker jackets, T-shirts and lingerie. She described the collection as having 'a slightly rocky feel, fabulously sexy with a strong, masculine edge'. Its success was followed by a second in spring 2012, adding jumpsuits and hotpants into the mix, as well as more lingerie – this time uplifting sparkle-bras.

As Rihanna's first foray into design, her work with Armani was affirmation of her own characteristic tomboyish sensibilities, framed with a sensual assertiveness that continues to thread through all her work as a designer to date. Acknowledging her talent, Mr Armani said at the time: 'She captures the young and contemporary essence of Emporio Armani Underwear and Armani Jeans perfectly.' It was an avowal that set her in good stead as she moved forward to show the world what else she had up her sleeve fashion-wise.

THIS PAGE: *Giorgio Armani at Milan Fashion Week, June 2022.*
OPPOSITE: *In Milan, wearing faded black jeans and a leather jacket from her Armani collection, 2011.*

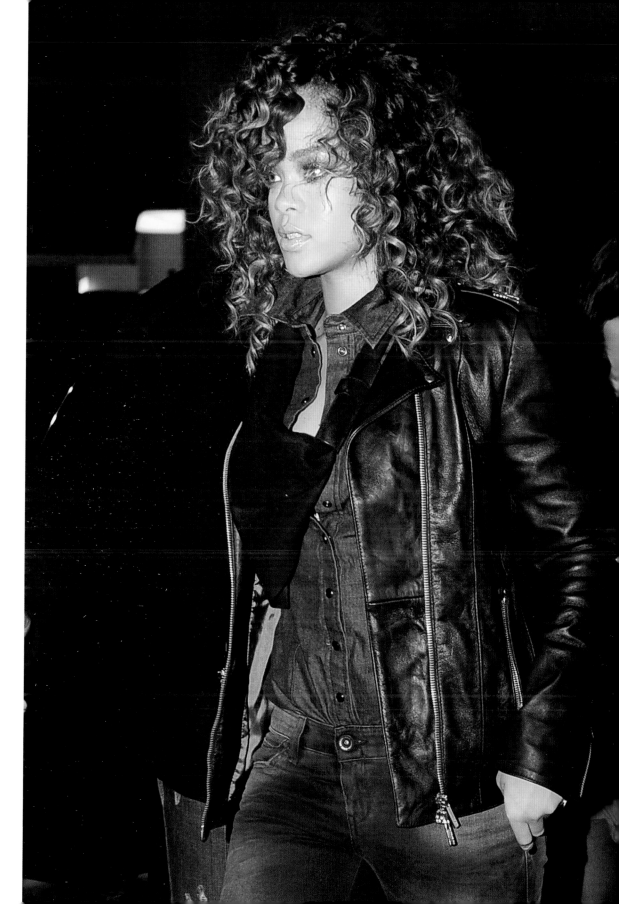

Bling Thing

When the Swiss watch and jewellery company Chopard announced Rihanna was working on a special collection to celebrate their 20th anniversary as Cannes Film Festival sponsor, it was a massive deal.

From 50 Cent's diamond earrings and matching necklaces to Gucci Mane's $250,000 iced-up teeth, the rapping glitterati has always worn its charms well, creating trends the rest of the world eventually follows. This high-profile creative partnership from both worlds clearly formalised the tacit relationship between the hip hop community and diamonds.

Rihanna's 2017 collection for Chopard was a stylish and credible takeover. Inspired by Barbados, Ri's earrings and necklaces were shaped like chandeliers, full of butterflies and flowers and shining bright in all the colours of the rainbow. Alongside this ultra-luxe range, RiRi created her own version of Chopard's signature classic 'Ice-Cube' – a chicly minimal dice-shaped design in 'Fairmined' 18-carat gold with an edge of deep 'jungle-green' shaded ceramic – another nod to Ri's home island.

OPPOSITE: *Arriving at the Chopard Space Party during the 2017 Cannes Film Festival.*
OVERLEAF: *Ri sparkles at the 57th Annual GRAMMY Awards, 2015.*

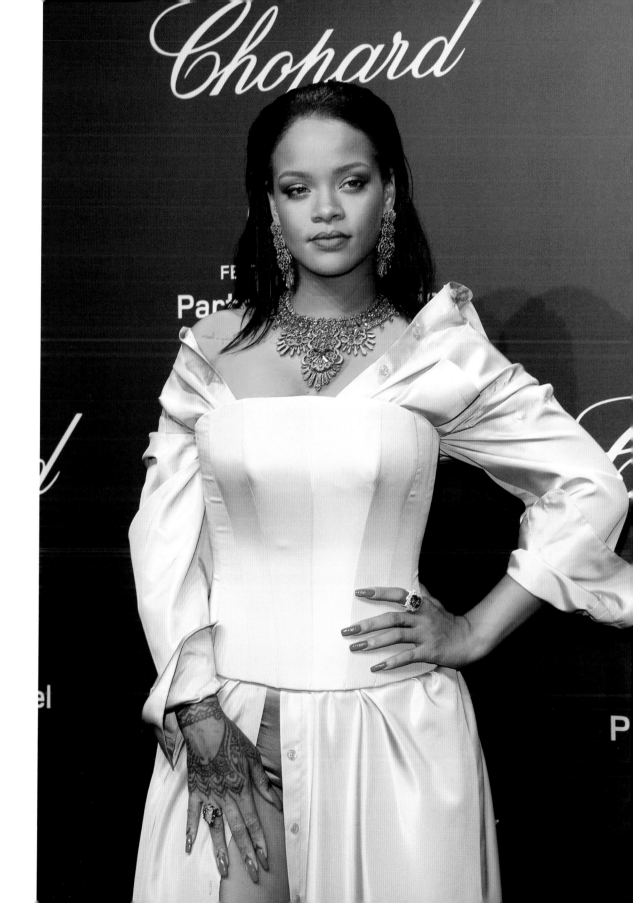

'I have always been in love with Chopard's exquisite jewelry, so to actually design collections with them is something I still can't believe. It was a really incredible process and I learned so much!

I can't wait for everyone to see it. '

— Rihanna, Chopard press release, May 2017.

Sock it to Them

' Together, Rihanna and Stance have the ability to take an accessory you've never thought about and transform it into one you can't live without. '

— Candy Harris, Executive Vice President of Stance Socks, *Refinery 29*, 2015.

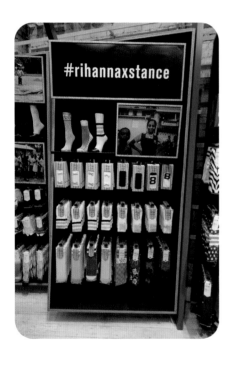

Stance is a sock company with friends in high places – rapper, entrepreneur and 'Mr Beyonce', Jay Z, invested in the company and sang about them in his 2013 track, 'F.U.T.W'. Rihanna's collaboration as Creative Director with Stance was therefore suitably super-fashionable and super-fabulous. The partnership began in 2015 and lasted a cool three years. During this time, the most fun foot-coverings imaginable were created. She started out with a 'Murder Ri Wrote' collection and continued aiming high with a 'Bitch What' *trompe l'oeil* toe sock, complete with red toe-nail varnish and designs plastered with money and gothic lettering. The two 'box-sets' of socks produced in 2017 were a classic example of Ri's imaginative creativity. The first was adorned with BadGal's CFDA 'naked' Adam Selman dress and the yellow Guo Pei Met Gala gowns woven into the fabric. The other featured the denim hotpants from her 'Pour it Up' video, and the dancehall red, gold, black and green net dress she wore for the 'Work' track promo. The launch press release explained the rationale: 'When you're the music industry's reigning Original Bad Gal, everybody wants a piece.' And Ri knows how to give it in the best possible taste.

THIS PAGE: *The New York Stance store ready for Ri's visit in 2018.*
OPPOSITE: *Taking a stance – Rihanna in her Stance socks, LAX, 2015.*

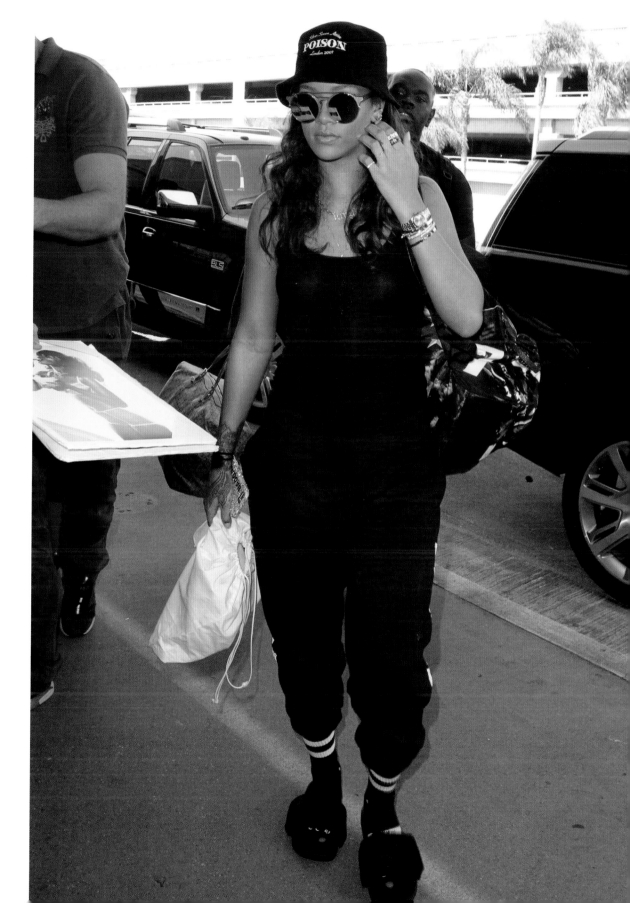

Fenty X Puma

● ●

' I'm inspired by attitude
more than anything. **'**
— Rihanna, *vogue.com*, February 2016.

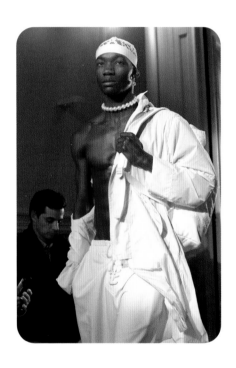

Bjørn Gulden, Puma's CEO, said in December 2014 when Ri was appointed Creative Director for Puma Womenswear: 'Her global profile, her charisma and individuality, her ambition – all these things make her a perfect ambassador for our brand.' A year later, she launched her first piece – the Puma Creeper Sneaker. With its rock and roll, teddy-boy crepe sole, it became an instant BadGal classic that Footwear News awarded its prestigious 'Shoe of the Year' award. Ri had originally commissioned LA designer, Mr Completely, to customise her Nike Air Force 1s with the sole and called on the brand to help design a Puma version. She would re-invent the shape time and again throughout her three years with the big sports name and go on to expand her footwear range to include satin bow detailing, stiletto boots and a fit, jelly flip-flop. All the while, she was warming up for the main attraction. In February 2016, she debuted her first Fenty X Puma collection during New York Fashion Week. She described the offering as: 'If the Addams Family went to the gym, this is what they would wear.' It was a luxe

THIS PAGE: *Catwalk – Rihanna's Fenty X Puma S/S show in Paris, 2016.*
OPPOSITE: *Wizard Ri, New York Fashion Week, February 2016.*

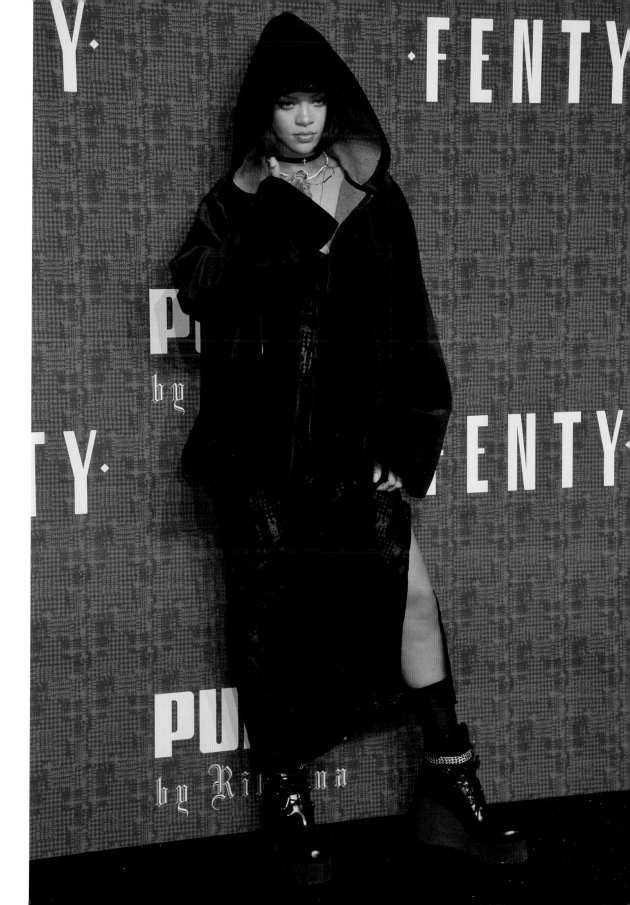

athleisure offering that mixed Goth with Harajuku twists and Lycra. It was a statement that felt in tune with the momentum of fashion at the time and catapulted Puma into the highest style arena. Rihanna was just getting started and over the course of her tenure she would produce three more full collections, showing twice in Paris. While with Puma, Ri made it her mission to do things differently. She began her journey to help introduce inclusivity into fashion and said in a 2017 *W* magazine interview: 'With [Fenty X Puma], I have so much freedom. I want everybody in my crew to have something. You don't just design for yourself. You use your taste as the muse of everything. I like to play around with silhouettes. Trust me, I could always use a good fat day outfit. I like to be comfortable.' When Ri takes on a new creative fashion venture, where she goes is always an evolution of her skillset as a designer. She made a big buzzy success of Puma, taking Puma X Fenty to the catwalks of Paris and New York, and was widely applauded by the fashion cognoscenti. Her next step via LVMH would take her even higher.

OPPOSITE: *BadGal wears Fenty X Puma to a Fenty X Puma afterparty in 2017.*

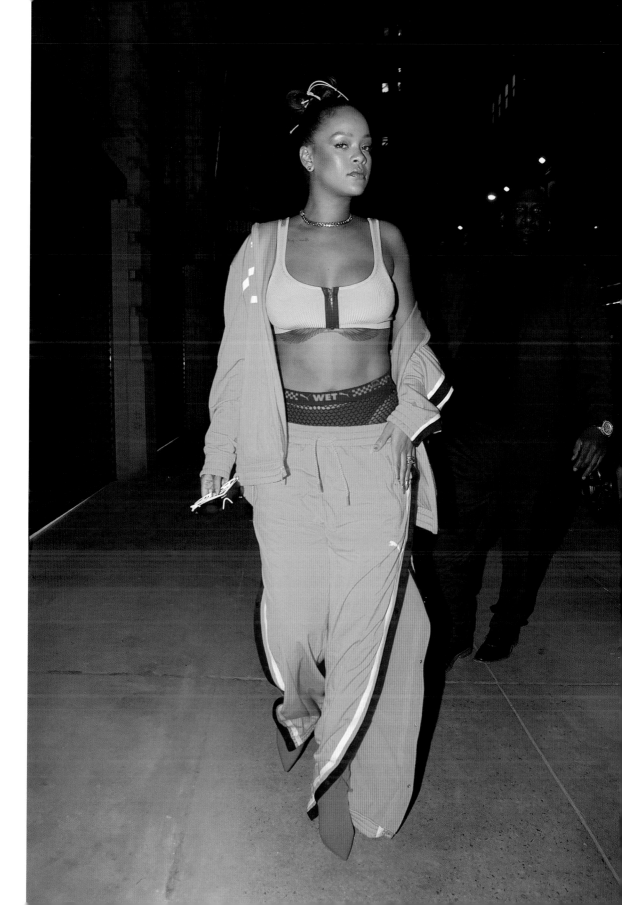

Maison Fenty

' There is huge diversity in the collection, which you will see as the new pieces come out, because that's my style. I'm all over the place, in sweats one day and a dress the next. '
— Rihanna, *Vogue*, 2019.

In 2019, when LVMH launched Rihanna's fashion house, Fenty, it was a big statement of intent. After many years of successful collaborations, it gave Ri a chance to spread her wings design–wise and flex her creativity autonomously. And it was big industry news. The French luxury conglomerate – which owns the most revered blockbusting companies, including Stella McCartney, Dior, Marc Jacobs, Fendi, Celine and Tiffany – had decided to open its first new Maison since Christian Lacroix back in 1987, and it was being headed by the first black woman in their entire history. They were already friends: a couple of years earlier, she had created a sunglasses range with Dior. At the time, Sidney Toledano, LVMH's current CEO observed that BadGal was 'an artist, an entertainer, an entrepreneur, a philanthropist, and a style icon for today's generation.' From the start, Rihanna made the decisions and made sure the brand did things differently. She didn't do seasonal collections. Instead, she 'dropped' pieces every now and again, often introduced via pop–up retail events – the first in the Marais district – to huge fanfare.

OPPOSITE: *Minty fresh in Fenty at The Fashion Awards, Royal Albert Hall, London, 2019.*

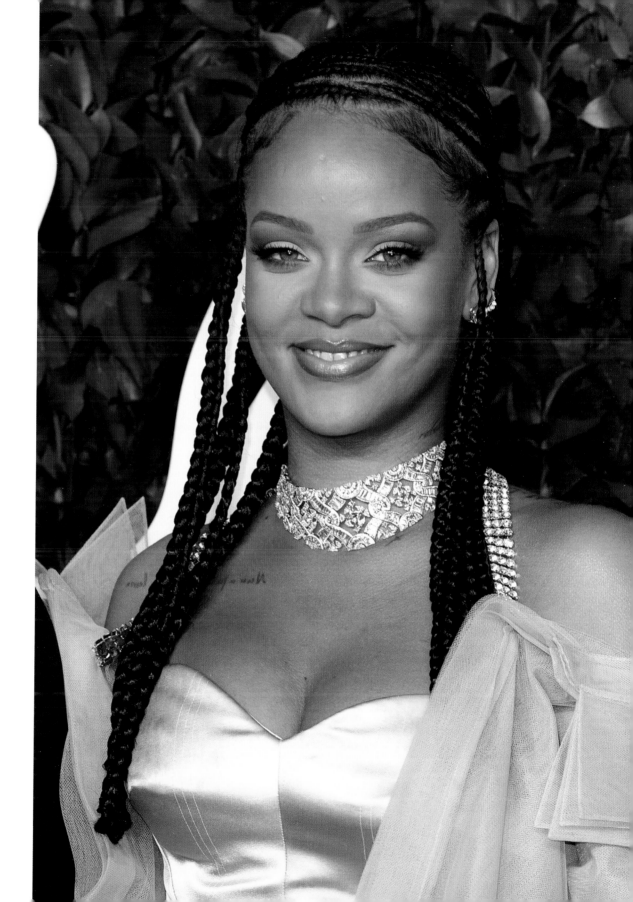

Unlike most traditional Parisian houses, she made inclusivity a priority and said to *Vogue* magazine: 'I'm a curvy girl. If I can't wear my stuff, then it just won't work. I need to see how it looks on my hips, on my thighs, on my stomach – does it look good on me or only on a fit model? It's important.' The clothes she designed reflected her own wardrobe classics and were made of exquisite fabrics and finishings. Prices were as luxe as the quality, but the collection had broad appeal and Ri aimed her silhouettes at everyone – men included. However, against the backdrop of the pandemic, two years after establishing the brand, Rihanna and LVMH made the decision to 'put the house on hold'. Despite this, Forbes reported that, 'Fenty Beauty and Fenty Skin, also LVMH owned, are performing exceptionally' – to date, they have a combined 14 million Instagram followers and counting. The BadGal message is still loud and clear, and she told *Time* magazine, who awarded her facecare ranges one of their '25 best inventions' award, that one way or another, 'I'm going to push boundaries in this industry.'

OPPOSITE: *À la maison – introducing a Fenty collection, Bergdorf Goodman, NYC, 2020.*

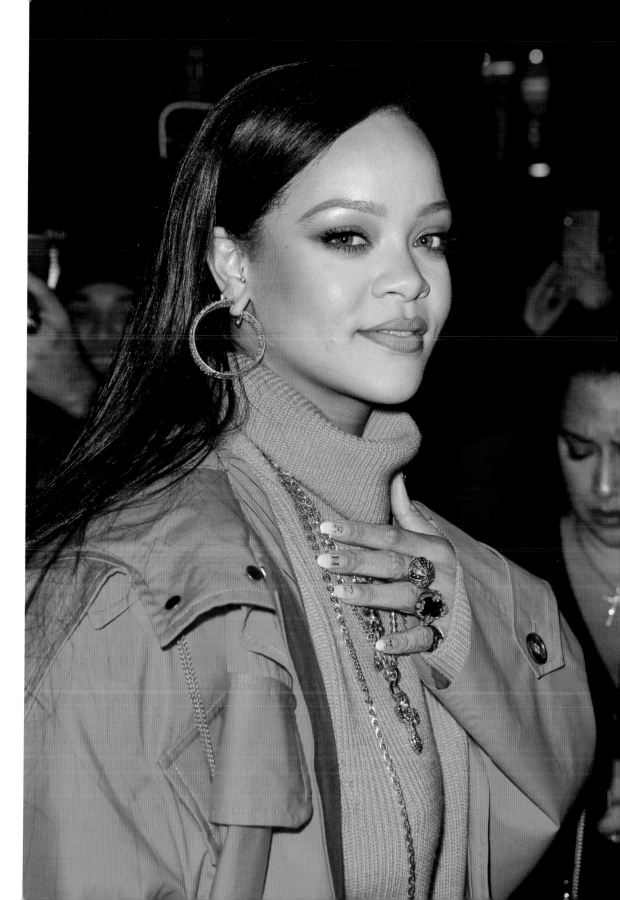

Keeping it Trill

· ·

‘We are women, and we have challenges, and we deserve to feel beautiful…. I don't want to sell anything I don't believe in. ’

— Rihanna, Knight Music Channel, September 2017.

From a marketing perspective, there isn't a better example of a new product launch than Fenty Beauty. Rihanna's 'Fenty effect' on the beauty industry helped seismically shift the paradigms of inclusivity. As Sandy Saputo, then–CMO of Kendo Brands, the mothership of Fenty Beauty, explained in a 2019 Google think piece: 'Hundreds of people started posting selfies of themselves wearing Fenty Beauty on social media; our first repost was of a beautiful woman wearing a hijab. And direct sales surpassed all of our estimations, crashing our website.' Social media overload meant huge sales, but it was their messaging that reverberated in a profound way, as Saputo went on to reveal: 'It was a call to action for all industries to do more and challenge the status quo. In beauty, it caused a chain reaction of brands that responded positively by expanding their make–up lines to be more inclusive.'

Today, brands can't exist without meaning. Post–pandemic, the frayed edges of superficial style–mongering has gone out the window. Companies strive to make consequential

THIS PAGE: *The Fenty Beauty line at Harvey Nichols in Birmingham.*
OPPOSITE: *Beauty queen, NYC, 2017.*

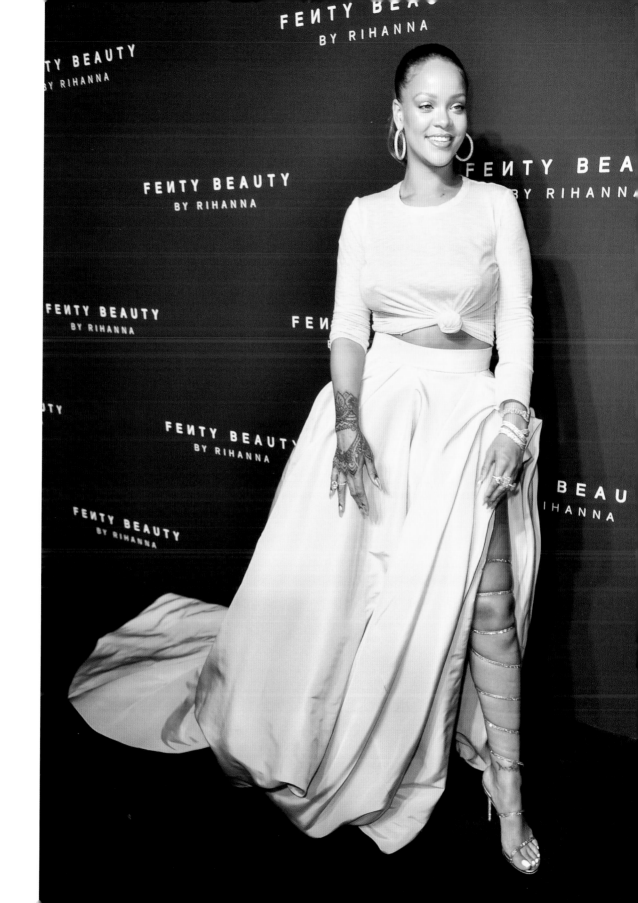

connections with their consumer. For Rihanna, it's straightforward. She told UK Fashion Network in October 2018: 'Every woman should have their shade of foundation. It's that simple.' Her own love of make-up is unequivocal, but she was a slow starter, admitting to *Access Hollywood* in 2020: 'I wasn't allowed to wear make-up till my school pageant and my mum did my make-up. And when I saw foundation on my skin. I was so hooked.' In 2020, Ri launched her skincare line, featuring amongst others, Jazzelle (aka @uglyworldwide) and Lil Nas in the campaign. Artist and model, Jazzelle revealed in an *i-D* magazine interview: 'Rihanna in herself is so inclusive of everybody, and not just in terms of race or gender or in that way, but also in terms of personality. Everyone she casts is so different, and I just felt really accepted.' The skincare range extended its remit to even more everyones – men were equally embraced this time, something that had been on her mind since the start of her Fenty Beauty journey. 'Venturing into skincare. I want representation for men too,' she had mused back in 2017.

OPPOSITE: *Fenty Beauty launches in Brooklyn.*

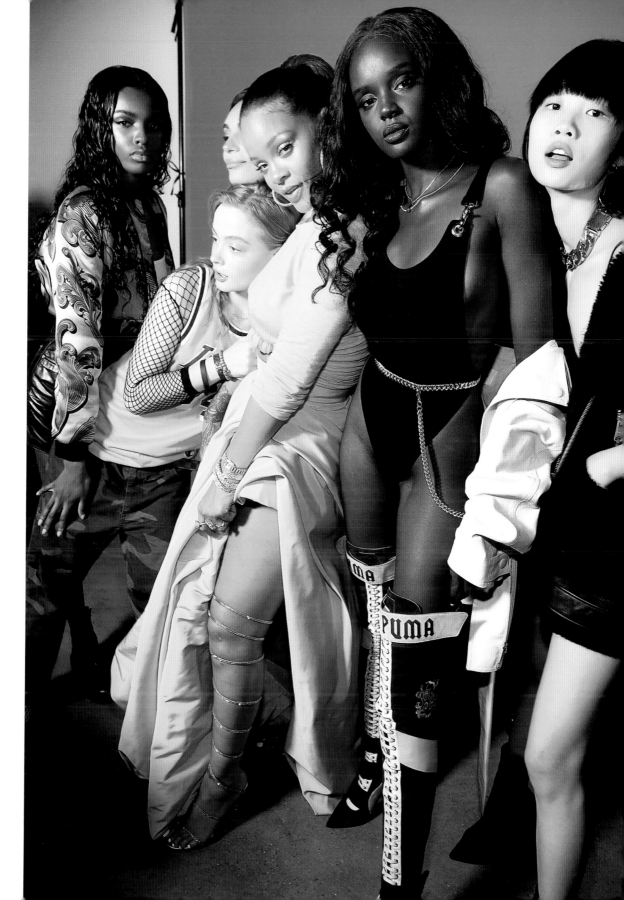

U Cute

' I want people to wear Savage X Fenty
and think, I'm a bad bitch.
I want women to own their beauty. '

— Rihanna, *vogue.com*, May 2018.

The sexy lingerie market needed disrupting when Ri decided to debut her Savage X Fenty line in 2018. The designs she created were fun and full of attitude and, as per her signature style, embraced a diverse clientele. Bras popped up in sizes 32A to 44DD, and everything else from XS to 4XL. Her first collection was live streamed on YouTube and included pregnant women wearing nipple pasties, walking the catwalk alongside supermodels, the Hadid sisters and Joan Smalls. It was the start of the fashion show as a TV Special. Her autumn 2019 event played live during New York Fashion week at The Barclays Centre in Brooklyn and aired the following day on Amazon Prime TV. Fully pumped, Ri spoke to Extra TV and reiterated her raison d'etre: 'I want women to feel comfortable whatever size they are, whatever shade of nude they are, no matter what their personality is, what their race is, their religion is, I want women to feel confident and sexy because that's who we are and we deserve to feel like that.' The Fenty X Savage extravaganza has become more than a lingerie show – it's the spectacle of Rihanna and her crew as they show off her cosmos of underwear and the way she

OPPOSITE: *A swing and a hit.*

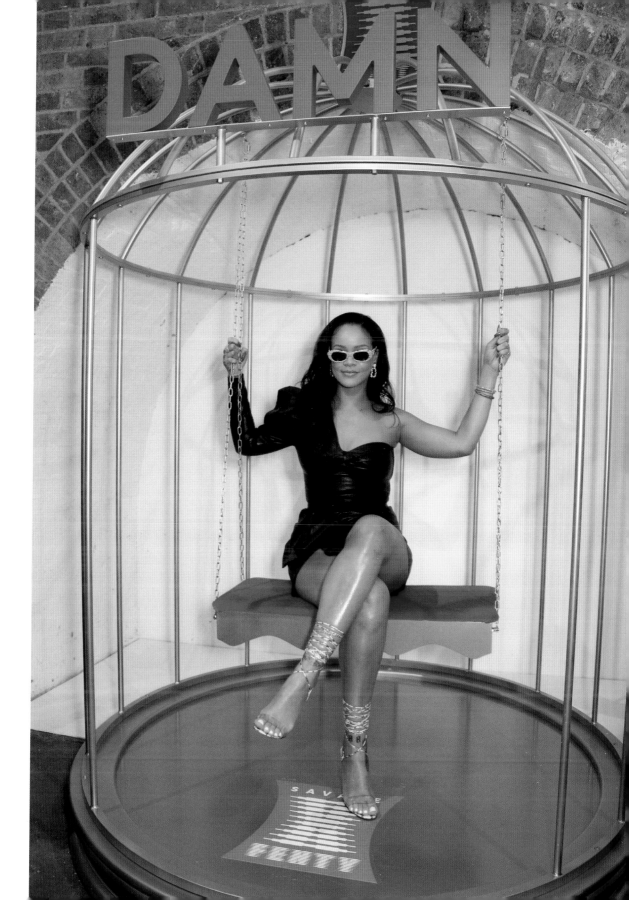

likes to wear it, strutting to the backbeat of tracks performed by a masterly rollcall of rappers like Tierra Whack and Fabolous. 2021's fiesta, set in the glass Westin Bonaventure Hotel in downtown LA, was a tableau of talent, showcasing a who's who of fashionable faces, including Cindy Crawford, Lourdes, Erykah Badu, Alek Wek and BIA – all wearing the fired-up fashion pants Ri knows how to design so well. And she goes from strength to strength. In 2021, her company was valued at $1 billion. In 2022, $3 billion. This is for a range initially launched online – only opening its first IRL shop in 2022, in Las Vegas. 'Every year we challenge ourselves to up the ante so to speak' she told *Titanium* magazine. When she received a 2022 FEMMY, her Twitter-broadcast acceptance speech told her fans: 'When we first started my vision had always been the celebration of the body and to continue to push the boundaries of what sexy meant, all built on the foundation of inclusivity. I'm so proud of how the brand has evolved over the last four years, with the launch of the men's category... And to our clients, you are the muses of this brand, so thank you for inspiring us always. More to come!'

OPPOSITE: *The Savage X Fenty Show presented by Amazon Prime Video in 2019.*

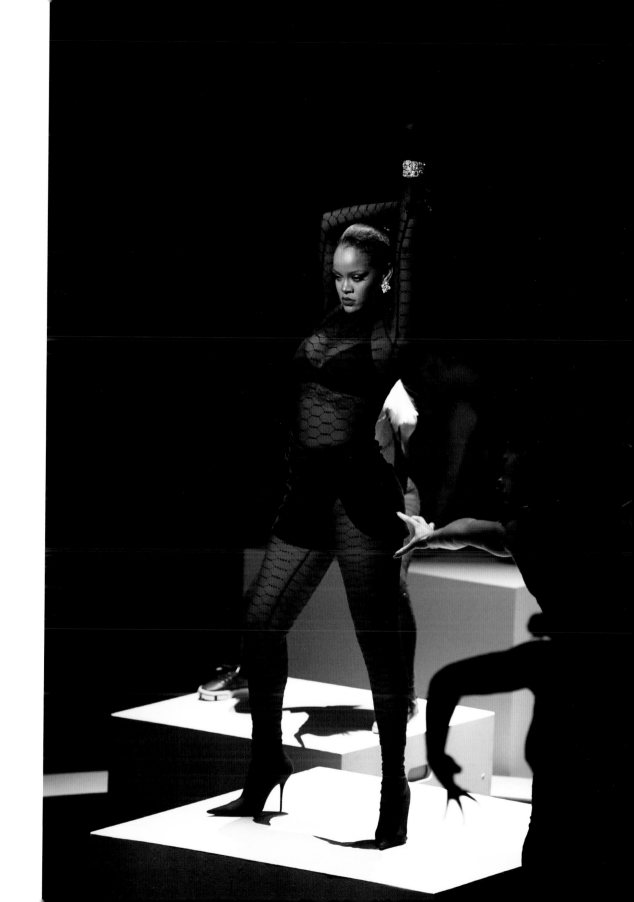

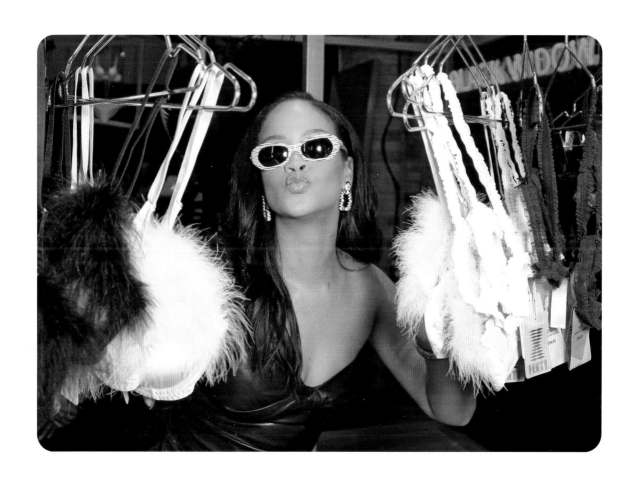

OPPOSITE: *Savage X Fenty in full bloom in 2020.*
THIS PAGE: *Ri pops up in London at the Shoreditch Savage X Fenty pop-up shop, June 2018.*

Big Her Up

· ·

Rihanna disrupted the status quo of maternity wear when she was expecting her first child and in doing so, forever changed the way pregnancy wardrobes can look. She wore silver mesh tops and matching miniskirts by Miu Miu. She wore latex cropped vests and chainmail headdresses by Gucci She wore nude leather dresses by Off White, all the time with her baby–bump as prominent as possible: no hiding, no dieting, no apologies. Shot by Annie Leibowitz for the cover of May 2022 *Vogue* magazine, she looked majestic, wearing a red lace Alaïa bodysuit, gloves, and shoes, with dazzling Chopard earrings. She didn't change her sartorial stride while she was expecting and said in the accompanying interview: 'As much as it's happening, it's also not happening. Sometimes I'll walk past my reflection and be like, Oh shit…. It's too much fun to get dressed up. I'm not going to let that part disappear because my body is changing.'

Rihanna's signature mission in fashion has been to promote inclusivity and diversity. While pregnant, she became a walking billboard for her purpose and personified everything

OPPOSITE: *Fenty Beauty. Fenty Skin.*

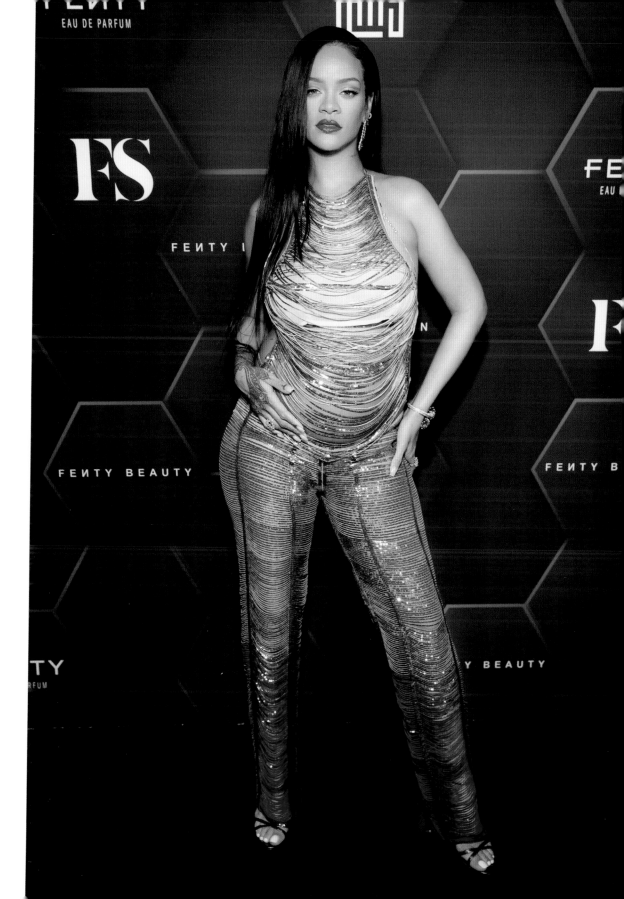

she has attempted to integrate into her work. Rihanna reframed the notion of femininity with the clothes she wore while pregnant, telling Access Hollywood: 'It's a challenge, but I enjoy a challenge. Figuring out first what fits and then go from there... How can we make it cool?' Rihanna's maternity wear is not just cool – from the get–go she admitted to a conscious aim of 'redefining what it even means to be pregnant and maternal.' Keeping strong is very much part of the process – revealing to Entertainment Tonight: 'It can get uncomfortable at times so you can dress the part and pretend.' Fashion's purpose has always been to reveal and define identity, but up till now, expectant women have been largely excluded from experimenting with style, as fashion's fixation with sexy–meaning–skinny has overruled a body that overtly displays its fecundity. That is unless BadGal has anything to do with it – she cast a pregnant Slick Woods for her September 2018 Fenty X Savage lingerie show and explained to E! Insider why: 'Part of womanhood is motherhood, and I'm never going to tell a woman she can't have a job with me because she's pregnant.'

OPPOSITE: *Riding the waves – Milan Fashion Week, February 2022.*

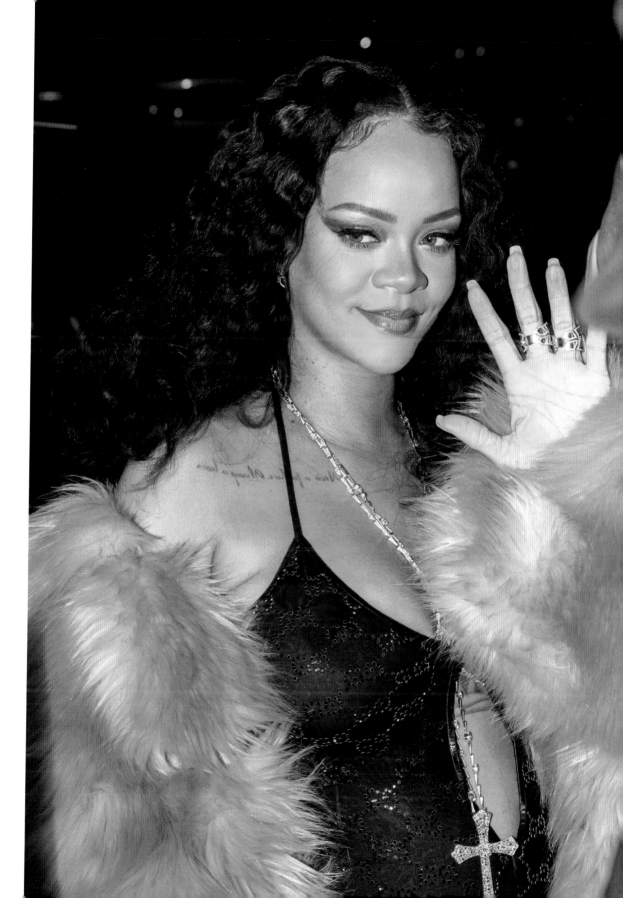

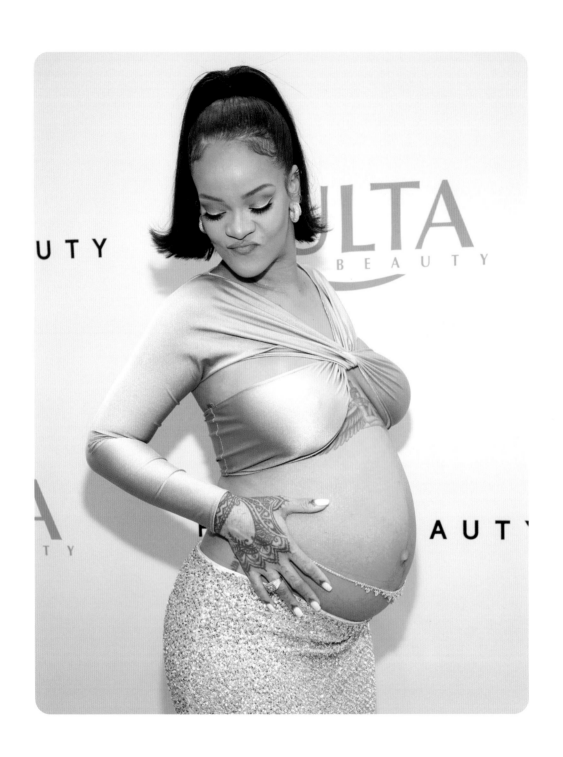

THIS PAGE: *Fenty Beauty launch, LA, 2022.*

'There's a pregnancy glow. There're also those days, girl. Especially in the third trimester where you wake up and you're like, oh, do I have to get dressed?... Everything is a challenge, from getting dressed and how you're going to do your makeup. But I like challenges. I like things that force me to be creative and create in new ways. '

Rihanna, *Elle.com*, March 2022.

Image Credits

COVER: Gonzalo Fuentes/REUTERS/Alamy Stock Photo
p.2 Kevin Mazur/Getty Images for Roc Nation
p.8 Francois Durand/Getty Images
p.9 Robert Kamau/GC Images/Getty Images
p.11 Arturo Holmes/WireImage/Getty Images
p.12 Bertrand Rindoff Petroff/French Select/Getty Images
p.13 Aurore Marechal/ABACAPRESS/Alamy Stock Photo
p.14 TOP Audrey Poree/ABACAPRESS/Alamy Stock Photo
p.14 BOTTOM Gilbert Carrasquillo/GC Images/Getty Images
p.15 Gilbert Carrasquillo/GC Images/Getty Images
p.16 Estrop/Getty Images
p.17 Clotaire Achi/REUTERS/Alamy Stock Photo
p.19 Gonzalo Fuentes/REUTERS/Alamy Stock Photo
p.20 TOP Alo Ceballos/FilmMagic/Getty Images
p.20 BOTTOM Bertrand Rindoff Petroff/Getty Images
p.21 Denis Guignebourg/ABACAPRESS/Alamy Stock Photo
p.22 Mark Ganzon/Getty Images for Fenty Beauty
p.23 Johnny Nunez/WireImage/Getty Images
p.24 Kevin Tachman/Getty Images for amfAR
p.25 Christopher Polk/Getty Images for amfAR
p.26 JP Yim/Getty Images
p.27 Kevin Mazur/Getty Images for Savage X Fenty
p.29 Danny Moloshok/REUTERS/Alamy Stock Photo
p.30 Bennett Raglin/Getty Images
p.31 Mario Anzuoni/REUTERS/Alamy Stock Photo
p.35 Philippe Wojazer/Pool/ABACAPRESS/Alamy Stock Photo
p.37 Mustafa Yalcin/Anadolu Agency/Getty Images
p.39 Randy Brooks/AFP/Getty Images
p.40 Randy Brooks/AFP/Getty Images
p.41 Randy Brooks/AFP/Getty Images
p.43 Paul Maroitta/Getty Images
p.45 Paul Maroitta/Getty Images
p.46 TOP TLeopold/Globe Photos/ZUMA Wire/Alamy Stock Photo
p.46 BOTTOM Jason Kempin/Getty Images for The Clara Lionel Foundation
p.47 Adam Orchon/Sipa USA/Alamy Stock Photo
p.49 Steven Ferdman/Getty Images
p.51 Gilbert Carrasquillo/GC Images/Getty Images
p.53 Evan Agostini/Getty Images
pp.54/55 Gregorio Binuya/ABACAPRESS/Alamy Stock Photo
p.56 John Angelillo/UPI/Alamy Stock Photo
p.57 Douliery-Taamallah/ABACAPRESS/Alamy Stock Photo
p.59 Lucas Jackson/REUTERS/Alamy Stock Photo
p.61 Erik Pendzich/Alamy Stock Photo
p.63 Scott Gries/Getty Images for Universal Music
p.65 Jackson Lee/Star Max/FilmMagic/Getty Images
p.67 Alo Ceballos/FilmMagic/Getty Images
p.68 Robert Camau/GC Images/Getty Images
p.69 Yui Mok/PA Images/Alamy Stock Photo
p.71 Robert Camau/GC Images/Getty Images
p.72 TOP Ron Galella Archive/Getty Images

p.72 BOTTOM Dominique Charriau/WireImage/Getty Images
p.73 Ricky Vigil M/GC Images/Getty Images
p.74 TOP Chris Jackson – Pool/Getty Images
p.74 BOTTOM Arnold Jerocki/WireImage/Getty Images
p.75 Han Myung-Gu/WireImage/Getty Images
p.76 TOP Thierry Orban/Sygma/Getty Images
p.76 BOTTOM Justin Tallis/AFP/Getty Images
p.77 Kevin Winter/Wire Image/Getty Images
p.78 John Atashian/Getty Images
p.79 Kevin Mazur/Getty Images for Fenty Corp
p.81 Christopher Polk/Getty Images for CBS Radio Inc
p.82 Mike Kemp/In Pictures/Getty Images
p.83 Raymond Hall/GC Images/Getty Images
p.84 Darren Gerrish/WireImage/Getty Images
p.85 ECP/GC Images/Getty Images
p.86 Jason Merritt/Getty Images for Clear Channel
p.87 Ignat/Bauer-Griffin/GC Images/Getty Images
p.89 GVK/Bauer-Griffin/GC Images/Getty Images
p.90 Jun Sato/WireImage/Getty Images
p.91 Nathaniel S. Butler/NBAE/Getty Images
p.93 Alex Moss/FilmMagic/Getty Images
p.94 Neil Mockford/FilmMagic/Getty Images
p.95 WENN/Alamy Stock Photo
p.97 WENN/Alamy Stock Photo
p.99 Jamie McCarthy/Getty Images for The New School
p.101 Dimitrios Kambouris/Getty Images for Stance
p.103 Larry Busacca/Getty Images
p.105 Kevin Tachman/WireImage/Getty Images
p.106 Tabatha Fireman/BFC/Getty Images
p.107 NCP/Star Max/GC Images/Getty Images
p.109 Robert Kamau/GC Images/Getty Images
p.110 Victor Virgile/Gamma-Rapho/Getty Images
p.111 PictureGroup/US/Alamy Stock Photo
p.113 Christopher Polk/Getty Images for NARAS
p.115 MEGA/GC Images/Getty Images
p.117 Michael Stewart/WireImage/Getty Images
p.118 Julian Parker/UK Press/Getty Images
p.119 Dave M. Benett/Getty Images
p.121 WENN/Alamy Stock Photo
p.122 Ian Gavan/Getty Images
p.123 Robert Kamau/GC Images/Getty Images
p.124 Pietro D'Aprano/Getty Images
p.125 Jacopo Raule/Getty Images
p.127 Gisela Schober/WireImage/Getty Images
p.129 Jason Merritt/Getty Images
p.130 Dimitrios Kambouris/Getty Images for Stance
p.131 GVK/Bauer-Griffin/GC Images/Getty Images
p.132 Jacopo Raule/Getty Images for Fenty x Puma
p.133 Kris Connor/WireImage/Getty Images
p.135 Robert Kamau/GC Images/Getty Images
p.137 Daniele Venturelli/Daniele Venturelli/WireImage/Getty Images
p.139 James Devaney/GC Images/Getty Images
p.140 Tony Woolliscroft/Getty Images for Fenty and Harvey Nichols
p141 Steven Ferdman/Patrick McMullan/Getty Images
p.143 Kevin Mazur/Getty Images for Fenty Beauty
p.145 David M. Benett/Dave Benett/Getty Images for Savage X Fenty

p.147 Dimitrios Kambouris/Getty Images for Savage X Fenty Show Presented by Amazon Prime Video
p.148 Kevin Mazur/Getty Images for Savage X Fenty Show Vol. 2 Presented by Amazon Prime Video
p.149 David M. Benett/Dave Benett/Getty Images for Savage X Fenty
p.151 Rich Fury/Getty Images for Fenty Beauty & Fenty Skin
p.153 Arnold Jerocki/Getty Images
p.154 Kevin Mazur/Getty Images for Fenty Beauty by Rihanna

References

https://www.teenvogue.com/story/rihanna-met-gala-2017-comme-des-garcons-dress

https://www.globalpartnership.org/blog/rihanna-takes-twitter-rally-world-leaders-education

https://www.rollingstone.com/music/music-news/barbados-rihanna-national-hero-1264532/

https://www.popsugar.co.uk/fashion/rihanna-white-skirt-suit-at-barbados-national-honor-ceremony-48631188?utm_medium=redirect&utm_campaign=US:GB&utm_source=www.google.com

https://news.harvard.edu/gazette/story/2017/02/rihanna-named-humanitarian-of-year/

https://time.com/5673371/rihanna-diamond-ball-2019/

https://www.vogue.com/article/rihanna-john-galliano-met-gala-liza-koshy-video

https://www.youtube.com/watch?v=49C3eEM5BW8&t=31s

https://www.revolt.tv/article/2021-09-14/100989/rihanna-explains-inspiration-behind-2021-met-gala-look/

Access Hollywood interview/Met Gala interview Guo Pei/

https://www.youtube.com/watch?v=ArMV1gOnhMQ

https://www.nylon.com/articles/fashion-designer-rihannas-crop-over-looks

https://pagesix.com/2019/08/05/rihanna-steps-off-airplane-in-a-red-carpet-ready-outfit/

https://fashionbombdaily.com/rihanna-was-pretty-in-pink-in-custom-david-laport-at-2019-crop-over-festival-in-barbados/

https://en.vogue.me/fashion/rihanna-first-public-appearance-after-giving-birth-son-black-feather-puffer-jacket-mom-style/

https://www.youtube.com/watch?v=0nUhsEpOq14

https://hausofrihanna.com/maison-margiela-couture-suit-grammys/

https://www.vogue.fr/fashion/article/rihanna-holiday-wardrobe-fenty

https://www.insider.com/rihanna-fashion-evolution-2017-2#later-that-month-she-took-a-risk-with-this-oversized-tan-pantsuit-by-matthew-adams-dolan-while-attending-the-69th-annual-parsons-benefit-36

https://www.yproject.fr/about

https://pitchfork.com/features/article/how-rihanna-became-the-most-stylish-pop-star-of-her-generation/

https://wwd.com/fashion-news/fashion-scoops/sean-john-womens-collaboration-missguided-1234591810/

https://www.billboard.com/music/music-news/rihanna-youngest-self-made-billionaire-1235110658/

https://www.complex.com/style/2014/08/mikey-trapstar-on-designing-monster-tour-merch

https://www.elle.com/fashion/news/a15415/adam-selman-rihanna-dress-cfda-awards-interview/

https://www.vogue.com/article/rihanna-fenty-puma-anti-april-2016-cover

https://www.refinery29.com/en-us/2014/12/79255/rihanna-cher-naked-dress

https://www.vogue.com/article/rihanna-fenty-puma-anti-april-2016-cover

https://www.vogue.com/article/word-on-the-street-why-hood-by-air-is-getting-front-row-attention

https://www.vogue.co.uk/news/article/rihanna-dior-john-galliano

https://www.vogue.co.uk/gallery/rihanna-launches-second-armani-jeans-collection

https://www.wmagazine.com/story/rihanna-fenty-puma-high-school-size-inclusion

https://www.elle.com/beauty/makeup-skin-care/a39442052/rihanna-fenty-beauty-ulta-interview/

https://www.thinkwithgoogle.com/future-of-marketing/management-and-culture/diversity-and-inclusion/-fenty-beauty-inclusive-advertising/

https://twitter.com/gabgonebad/status/1555410578272919554

https://www.vogue.co.uk/gallery/fenty-lvmh-launch-rihanna

https://www.youtube.com/watch?v=c_O7DPiSx0s

"The Stage Hip-Hop Feminism Built: A New Directions Essay." Signs, vol. 38, no. 3, 2013, pp. 721–JSTOR, https://doi.org/10.1086/668843. Accessed 19 Sep. 2022.

https://www.theguardian.com/music/2008/may/23/urban

Acknowledgements

Many thanks to Carrie Kania at Iconic Images as well as James Smith, Craig Holden, Susannah Hecht and Stewart Norvill, and all at ACC Art Books. Also, to Andrew, Freddie, William and Chop Newman, Mick Rooney, Gina Gibbons, Pippa Healy, Michael Costiff, Francine Bosco and Jo Unwin for their love and encouragement.

Biography

Terry Newman is a fashion historian who worked in the industry for over 15 years as a journalist and stylist and now writes about fashion, art, and culture. Recent books include *Legendary Authors and the Clothes they Wore, Legendary Artists and the Clothes they Wore* and *Harry Styles and the Clothes he Wears*. During the 1990s, she was employed as Shopping Editor at *i–D* magazine, Associate Editor at *Self Service* magazine, and Consumer Editor at *Attitude* magazine, and as a TV presenter for Channel 4 Fashion Programmes. Her journalism has been published in the *Guardian, The Times* and *The Sunday Times, Viewpoint* and the *Big Issue*, amongst others and she has contributed to i–D's *Fashion Now, Fashion Now 2* and *Soul i–D* books. Newman currently lectures at Regents University London, The University of West England, and The University for the Creative Arts. She lives in London with her husband, two sons and an English Bulldog.

' I love being black.
So, sorry for those who don't like it —
 that's the first thing you see before
 you even hear my voice.
There are also other factors: I'm
young. I'm new to the family.
I'm a woman.
Those factors do come into play,
but I will not apologize for them, and
I will not back down
from being a woman,
from being black, from
having an opinion. ,

Rihanna, *NYT*, May 2019.

ISBN: 978-1-78884-221-1

British Library Cataloguing–in–Publication Data
A catalogue record for this book is available from the British Library

Editors: Stewart Norvill, Susannah Hecht
Designer: Craig Holden

Cover: *Rihanna poses during a photocall before the French fashion house Christian Dior Fall/Winter 2017–2018 women's
ready–to–wear collection during Fashion Week in Paris, 3 March 2017.*
Frontispiece: *In Feb '23, Rihanna strutted onto the Super Bowl 57 field in a jumpsuit, silk catsuit and leather breast–body–
mould. But the flare–red Loewe outfit wasn't the only surprise – underneath was baby–bump number two! After a sassy
reapplication of Fenty Beauty's Invisimatte Blotting Powder, Ri shrugged on a matching Azzedine Alaïa sleeping–bag coat
and Pieter Mulier gloves, leaving everyone bowled over..*

Printed in Slovenia
for ACC Art Books Ltd., Woodbridge, Suffolk, UK

www.accartbooks.com